Botanical
Sketchbook

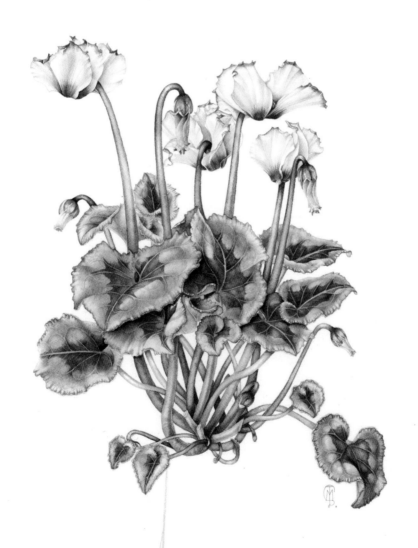

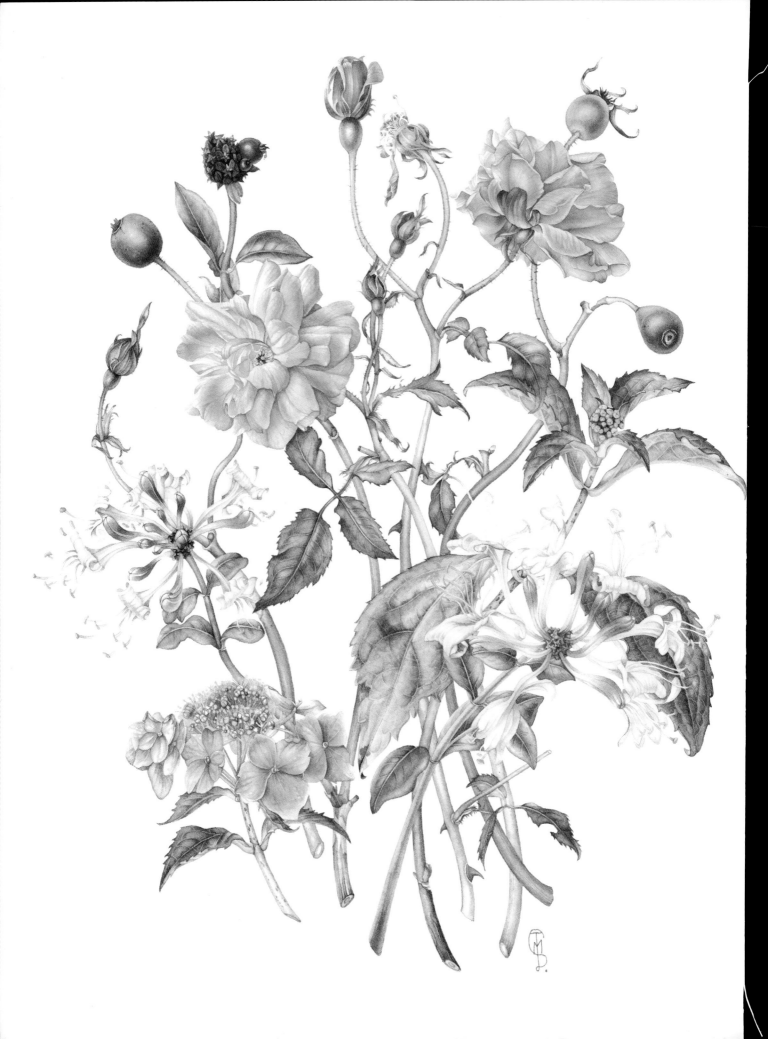

Botanical Sketchbook

Mary Ann Scott
with Margaret Stevens PSBA

in association with
The Society of Botanical Artists

BATSFORD

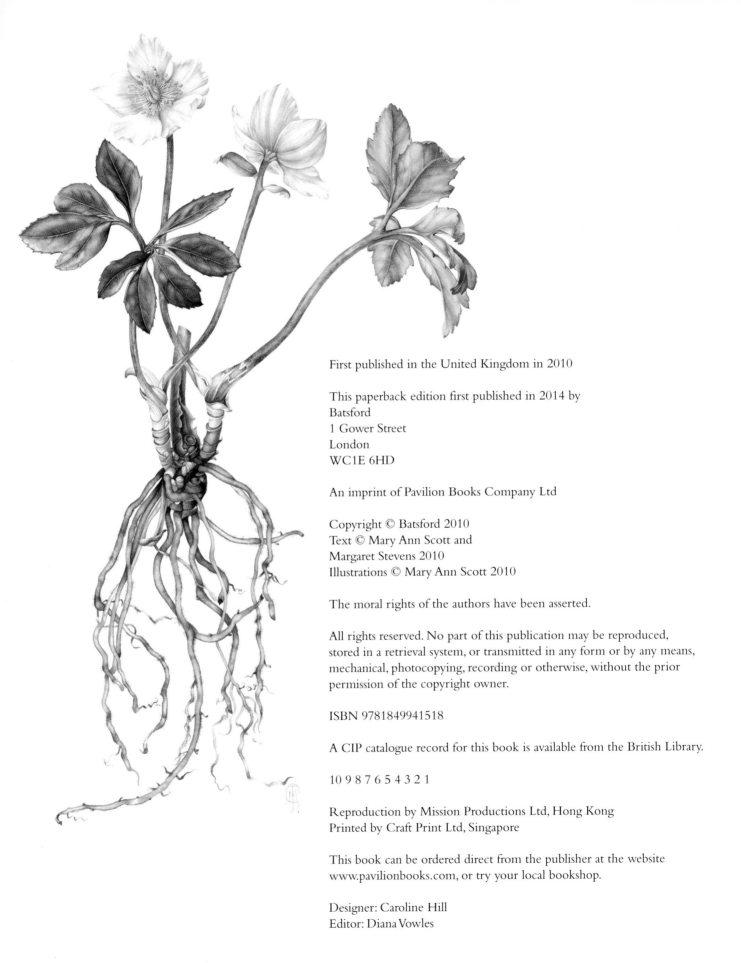

First published in the United Kingdom in 2010

This paperback edition first published in 2014 by
Batsford
1 Gower Street
London
WC1E 6HD

An imprint of Pavilion Books Company Ltd

ISBN 9781849941518

A CIP catalogue record for this book is available from the British Library.

10 9 8 7 6 5 4 3 2 1

Reproduction by Mission Productions Ltd, Hong Kong
Printed by Craft Print Ltd, Singapore

This book can be ordered direct from the publisher at the website
www.pavilionbooks.com, or try your local bookshop.

Designer: Caroline Hill
Editor: Diana Vowles

Contents

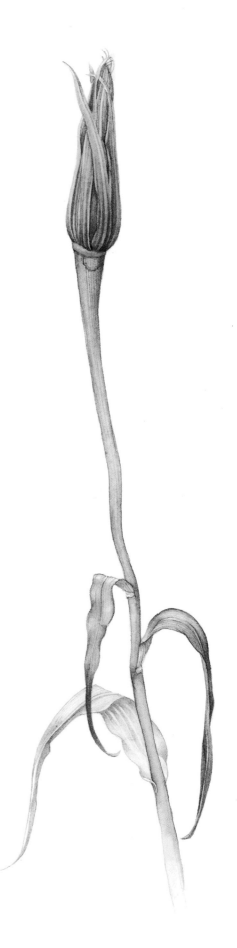

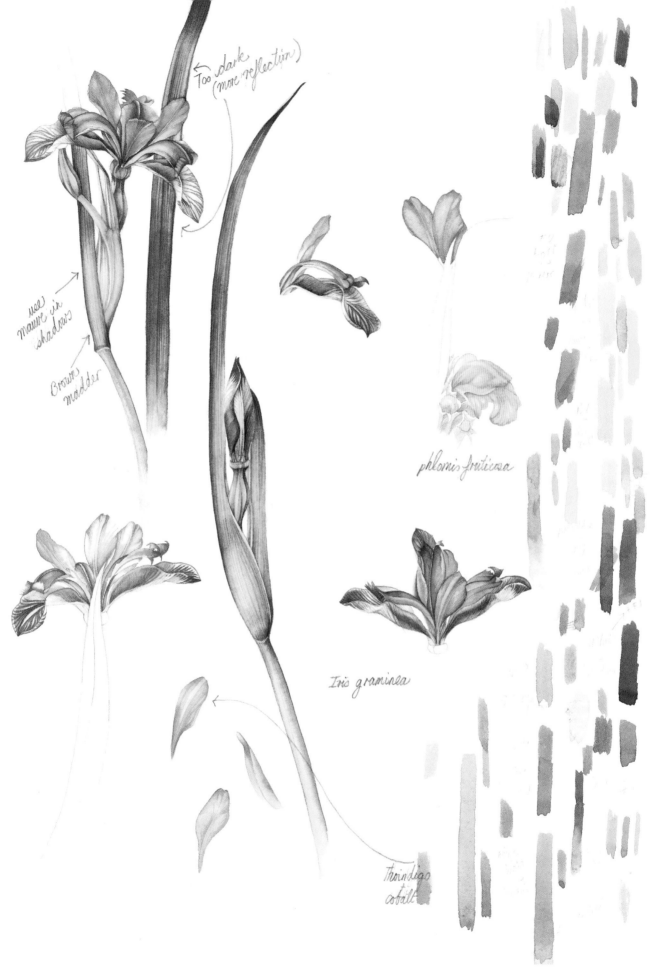

Too dark (more reflection)

use mauve in shadows

Brown madder

phlomis fruticosa

Iris graminea

thioindigo cobalt

Foreword

The revival of botanical painting during recent decades is one which has given me great personal joy and delight. As we now live in an age when the teaching of drawing from life as part of art-school training has been virtually abandoned, the art of botanical drawing and painting keeps alive a rare and disciplined skill. This, therefore, is a timely and beautiful book, which opens a door to its acquisition. As in the case of anyone wishing to acquire such a talent, it calls for patience, discipline and application. For any student it will also have its ups and downs, which is an enlivening part of what is recorded here.

This is a book strong on practicalities and constructive comment. Everything from paper, pencils and paint to the problems of composition are discussed and carefully considered. I cannot recommend this book enough to anyone tempted to try their hand at acquiring this skill. It also works from that wonderful premise, encouragement. Start by reading and studying this publication from start to finish and then, undaunted but under proper instruction and guidance, begin.

Sir Roy Strong

Left: Iris graminea *and Jerusalem sage.*

Introduction

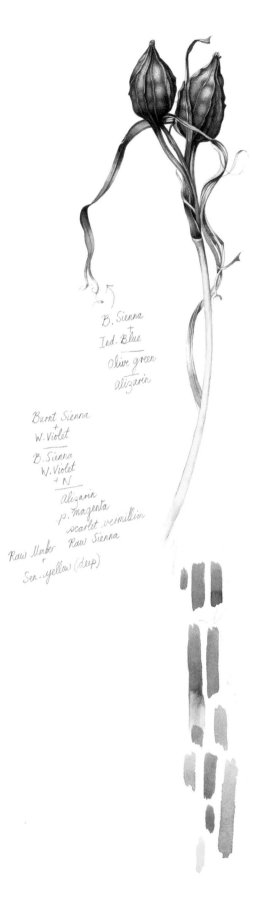

B. Sienna
Ind. Blue
olive green
alizarin

Burnt Sienna
+
W. Violet

B. Sienna
W. Violet
+ N

alizarin
p. magenta
scarlet vermillion
Raw Umber Raw Sienna
+
Sen. yellow (deep)

Above: Iris graminea *seedhead.*

This book is based upon the Distance Learning Diploma Course run by the Society of Botanical Artists. The course started as the result of a chance remark by my commissioning editor at Harper Collins, Cathy Gosling, when I completed The Art of Botanical Painting *in 2004. Cathy said that it would make a great textbook on which to base a course, so my colleague Pam Henderson and I put our heads together and the first course began in January 2005. Over the course of 27 months, the student is taken through all aspects of botanical art in a series of assignments which are marked by tutors who are all SBA members and experts in their particular field. Currently, 30 tutors mentor approximately 180 students, who come from all over the world.*

Mary Ann Scott joined the third course in January 2006. She showed promise in the early assignments but we were not prepared for what was to come. After a tricky patch, during which she could so easily have become disheartened and given up, it was as if a light was switched on. Her marks shot up and by the time we examined her Diploma Portfolio it was obvious that she was genuinely gifted. Her sketchbook was a joy, and special thanks go to Cathy Gosling and publishers Anova for having the vision to put into print what I hope will inspire others to persevere and draw out their hidden talent.

Margaret Stevens PSBA

Looking back, I can see two threads weaving through my life and gradually coming together. One is my love of painting and the other is my affinity with the natural world, in particular flowers and gardens.

The first thread began to form with the paintboxes and colouring books of my childhood. The second had more recent origins. When I left university I went to live at Benton End in Suffolk, the former home of the influential artist and plantsman Sir Cedric Morris. Sadly, the gardens had become a wilderness after his death, yet many shrubs and resilient perennials had managed to survive. Here I began learning about plants, and I have many memories of that enchanted place.

The threads began to converge when I moved to Denmark and started an apprenticeship at the Royal Copenhagen porcelain factory. I was hoping to join the select group employed in painting the Flora Danica service, and with this in mind I worked hard at home painting flowers and trying to improve my technique. I also began attending evening classes in botanical painting taught by Victoria Friis. Victoria had worked at Kew as a botanical illustrator and was an excellent teacher. We became friends, and I am grateful to her for gently setting my feet on the path.

I then moved to northern Italy and spent the next few years looking after my two children, working with horses and teaching English. It was only when a series of unfortunate events convinced

me to give up riding that botanical painting took precedence again. However, I now felt that I needed to learn how to depict flowers accurately from life rather than copying from photographs, as I had done before. I bought *The Art of Botanical Painting* and read about the Distance Learning Course. My first reaction was to say, 'I'll never manage this!' but my husband was confident that this was the best way forward – so in January 2006 I found myself putting my first assignment into the now familiar brown SBA envelope, my feet set well and truly on the path of botanical painting again.

The course taught me the fundamentals of botanical illustration. It also brought me into contact with many people with whom I could share my enthusiasm for this beautiful art form. At the seminar held halfway through the course I met my fellow students and many of my tutors. Here, for the first time, I met Margaret, and was instantly struck by her extraordinary energy and insight. I will always be grateful for her perspicacity, which helped to create the marvellous experience of turning my sketchbook from a working tool into a book that I hope will encourage other aspiring botanical artists.

Mary Ann Scott

Left: Nasturtium.

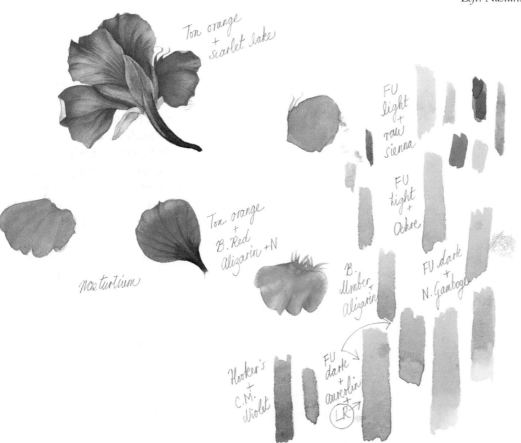

ASSIGNMENT 1

Drawing

Margaret Stevens: *A wise student realizes that the first assignment is arguably the most important, whereas a less astute one sees it instead as a chore to be got through quickly. A question such as 'Do I need to use my "good" paper for this?' is a sure indicator of the latter attitude, to which my reply is: 'Drawing is not inferior to painting but its equal.'*

From the elegant 15th-century lily by Leonardo da Vinci to the outstanding contemporary botanical drawing by artists such as Julie Small SBA, there are many examples to prove that a good drawing can be as valuable and sought after as a painting. Moreover, drawing is the foundation on which to build, because it encourages the essential skills of observation and eye-to-hand coordination, and an appreciation of tonal variation.

Mary Ann Scott: For the first assignment we were asked to produce three pieces of work, each demonstrating a different technique. The first was to be a simple line drawing and the second a small study of a single flower with attached leaf and stem, either hatched or stippled, both in either pencil or ink. The third piece was to consist of a complete study in pencil of a subject of our choosing, using the continuous–tone technique.

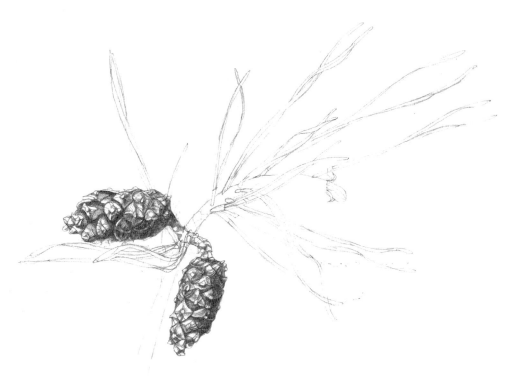

Above: Pine cones.

I launched myself into this brimming with confidence. I may not be the best watercolourist, but I knew how to draw – or so I thought! As it turned out, my self-confidence was not wholly warranted, and pride took a fall at this first hurdle. In retrospect, my real regret is that I didn't try harder, especially in the first two pieces. My rather cursory approach to the humble pencil resulted in a wasted opportunity. Since then I've had the chance to look at some striking works in pencil and ink in books and galleries, and my respect for this simple yet beautiful and difficult medium grows constantly.

MATERIALS

Before starting on the suggested exercises I bought a selection of good-quality graphite pencils that would produce a variety of tones ranging from the light grey of 2H to the velvety-black B grades. Paper was more of a problem. Most of the assignment work was carried out on cartridge paper, but I have since found that a sheet of 300gsm (140lb) HP watercolour paper provides a more sympathetic surface. I rest my hand on a scrap of the same paper, which protects my work from smudges, absorbs any grease from my hand and is useful for testing a pencil. I like to sharpen my pencils to a long point with a craft knife. For taking measurements I prefer to use dividers rather than a ruler, holding them at right angles to my hand and at arm's length.

THE EXERCISES

A series of exercises to improve basic drawing skills was given. The first involved filling small squares with horizontal lines, lifting the pencil at the end of each stroke and using a progression of pencils from H to 2B. Other exercises included cross-hatching with an HB or different combinations of pencil grades, stippling and shading various shapes with the lines following the contours. A useful exercise for practising long, curving lines consisted of starting with the pencil at the bottom of the paper, looking at a point at the top and aiming for it in one smooth action.

TULIP

When I had worked my way through the exercises and felt that I was beginning to develop a feel for the tonal and textural possibilities of my pencils, I decided to make a start on the line drawing. This should show a nice flowing line, so it was important to choose a flower or leaf with simple, sculptural qualities.

I attempted a hellebore leaf and then a pansy, but eventually I settled on the ubiquitous tulip. I tried hard to make my line 'flow', but it seemed to be more of a stutter. Perhaps I needed to practise the long sweeping curves more to relax my arm and produce the confident, clear line the tulip deserved. As my tutor later observed, the result was rather messy, as I had not taken care to erase the construction lines, which gave a ragged look to the drawing. I had taken careful measurements and tried to make an accurate representation, but in doing so I had lost the sense of movement, and the graceful curve of the stem and leaves.

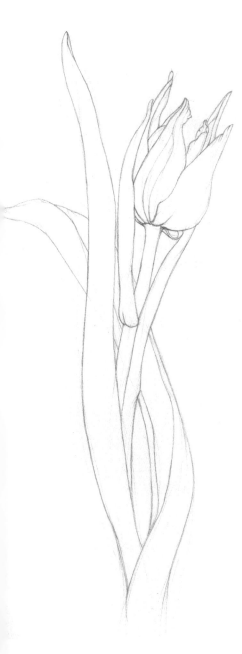

Above: Tulip.

A well-made line drawing is the foundation of a successful watercolour painting. I sometimes find myself tearing up a painting when I realize that it is not working because of mistakes in the original drawing. Errors of perspective or proportion are often at the root of the problem, or perhaps I had not spent enough time in careful observation before I began. I have learnt that it is important to study the plant carefully, moving it through 360 degrees and using a magnifying lens when the structure of something is difficult to understand.

PANSY

For the second piece of work, a small study of a flower such as a pansy or camellia was suggested, stippled or hatched. I chose a pansy as I thought I would enjoy drawing its flounced petals, which remind me of velvet drapes. Unfortunately I became obsessed with the elaborate 'coastline' of the petals, and my attempts to depict every crease and bump made me lose sight of the overall structure. Imprecisions in the leaf attachments and flower centre were pointed out by my tutor, which again underlined the importance of careful observation. When tiny details of a plant are unclear, I find it can be useful to sketch them while looking through a magnifying lens before including them in the final drawing.

CHRISTMAS ROSE

I had never drawn continuous tone, so the third study enabled me to explore this new technique. I looked for something that would make an interesting composition and provide opportunities to investigate texture and tone without being too challenging. In my wintry garden I caught sight of the leathery green foliage of *Helleborus niger*, the Christmas rose, with its small fat buds just beginning to unfold between the bare twigs and withered leaves. I knew that in this post-festive season the nurseries would be full of pots of unsold *Helleborus* and I thought this could be an excellent choice, particularly as a potted plant would last much longer in a warm room. I had learned by now that a pencil study required much time and patience.

The flower stems of *Helleborus niger* are leafless, although the bracts resemble leaves. I wanted to convey their strong, fleshy character and snakeskin texture and the way they emerged from the sheaths at the base of the plant. It was important to relax in order to avoid hard lines and to achieve smooth tonal transitions, so I tried to remember not to grip the pencil hard between my fingers, letting the action come down my arm from my shoulder without tension. Moving the pencil with small, elliptical movements and passing from lighter to darker areas, I found that much patience was required in building up tone; it was essential not to hurry or try to press down hard with the pencil in areas of heavier shading.

On this occasion some time spent studying the pattern with a lens would have helped. I also made the mistake of paying too much attention to the textural detail without having first concentrated on conveying the roundness of the stems convincingly. I was happy about the way I had managed to draw the movement of the leaves, but I should have put more effort into working them up. My intention was to show their leathery, glossy surface by leaving highlights untouched, but the overall effect was

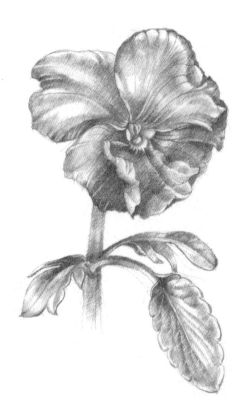

Above: Pansy.

too light and out of character. More tonal development would have created contrast and depth, helping to emphasize the whiteness of the flower. White on white can be problematic, perhaps no less so in pencil than paint. 'Less is more' is the dictum in this case.

In drawing the open flower I became once again obsessed with every fold and indentation of the petals, losing sight of the simple cup shape of the flower. Further difficulties were created in my efforts to record the complexities of the stamens and carpel.

As my tutor pointed out, more definition was required and a sharp pencil would have helped, as in the depiction of the textural detail on the stems. I was happy with the buds, however; I liked the way they gradually emerged from the base in different directions.

Below: Christmas rose.

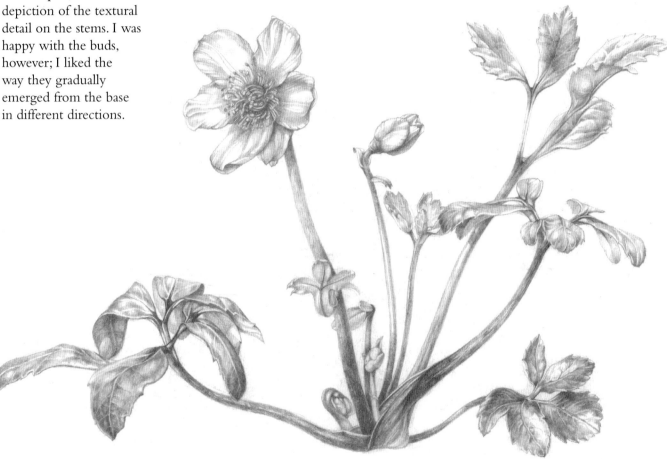

TUTOR'S COMMENTS

Mary Ann was quick to learn from this first assignment, although she would naturally have been disappointed by the very average mark of 66 per cent it earned. Her observational skills were first rate but, as a novice, she did not appreciate just how much effort was needed to translate what she saw into a three-dimensional image on paper. Her tutor, Julie Small, gave her some good advice on how to improve and fortunately Mary Ann took it in good spirit rather than feeling that the assignment had been harshly judged.

ASSIGNMENT 2

Leaves

Margaret Stevens: *It may seem odd to place the leaf assignment before the one on flowers. The reason is a simple one: it is the order of importance that dictates its position. Too often an inexperienced botanical artist places all the emphasis on the flowers and treats the leaves as something of a nuisance. Many a potentially good painting has been spoilt by foliage where the venation is poorly described, the perspective of twists and curls is given insufficient attention and, in a major mistake, the colour is one boring shade of boiled-cabbage green throughout. Worse still is the use of harsh Viridian, which does not exist in nature and is best avoided except as part of a mix, and even then handled with great care.*

The page of leaves for this assignment gives the student a chance to try out different shapes and to explore the huge range of greens that can be mixed from a few blues, yellows, reds and browns.

Mary Ann Scott: I found this rather a daunting task – the leaf with its elaborate serrations, lobes, midribs and veins pitched against me, armed only with a magnifying lens, dividers and pencils. It did not feel like a fair contest so I started with some trepidation, but by the end I was beginning to feel more confident and enjoyed painting the leaves for their own sake rather than as a necessary exercise.

Left: Ivy leaf.
Below: Honeysuckle leaf.

Ivy

Lonicera fragrantissima

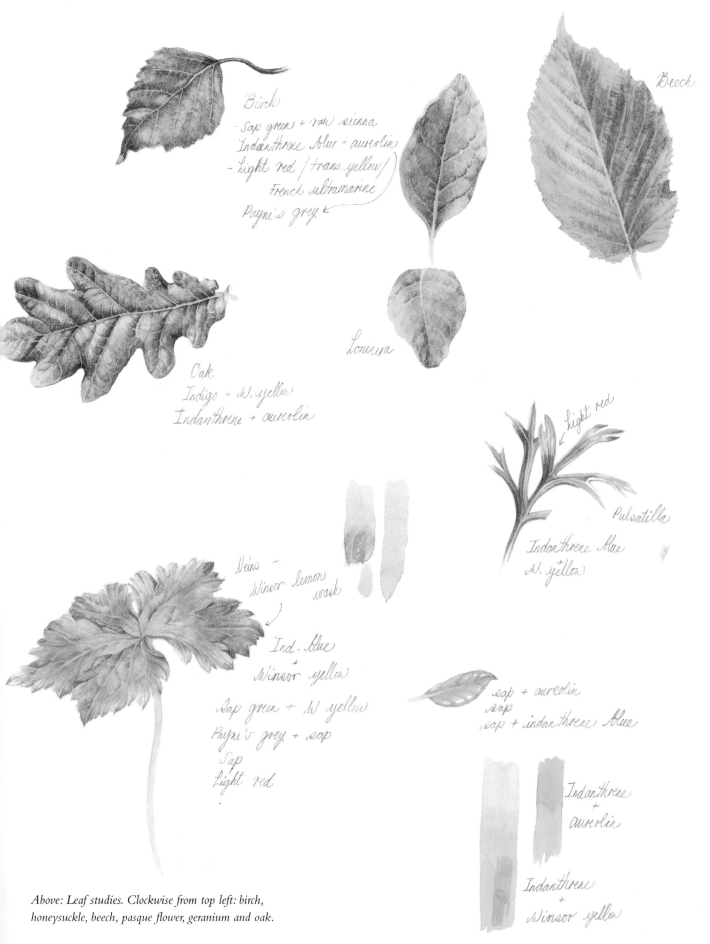

Birch
- Sap green + raw sienna
 Indanthrene Blue + aureolin
- light red / trans. yellow/
 French ultramarine
 Payne's grey

Beech

Oak
Indigo + W. yellow
Indanthrene + aureolin

Lonicera

light red

Pulsatilla
Indanthrene Blue
+
W. yellow

Veins -
Winsor lemon
wash

Ind. Blue
+
Winsor yellow
Sap green + W yellow
Payne's grey + sap
Sap
Light red

sap + aureolin
sap
sap + indanthrene Blue

Indanthrene
+
aureolin

Indanthrene
+
Winsor yellow

*Above: Leaf studies. Clockwise from top left: birch,
honeysuckle, beech, pasque flower, geranium and oak.*

THE SHADE CARD

My first task was to make a green shade card. I began by mixing a selection
of blues and yellows, to which I added Payne's Grey and Raw Umber, as
they were useful for making some subdued greens that verged on grey.
After working through the blues I started mixing some of the greens
in my palette with the yellows, adding Light Red, Alizarin Crimson and
Permanent Mauve. I found that experimenting like this was an excellent
way to learn about my colours. Not only did I become more aware of the
range of greens that could be mixed from relatively few pigments, but
I became more sensitive to colour bias, noting how certain combinations
resulted in warmer or cooler greens. I also started to think more about
transparency and opacity, which are important to consider when glazing.

LEAF SHADE CARD

	Indanthrene Blue	Sennelier French Ultramarine Dark	Sennelier French Ultramarine Light	Cobalt Blue	Prussian Blue	Winsor Blue (Green)	Cerulean	Payne's Grey	Viridian
Sennelier Yellow Deep									
Cadmium Yellow Pale									
Aureolin									
Cadmium Lemon									
Raw Umber									

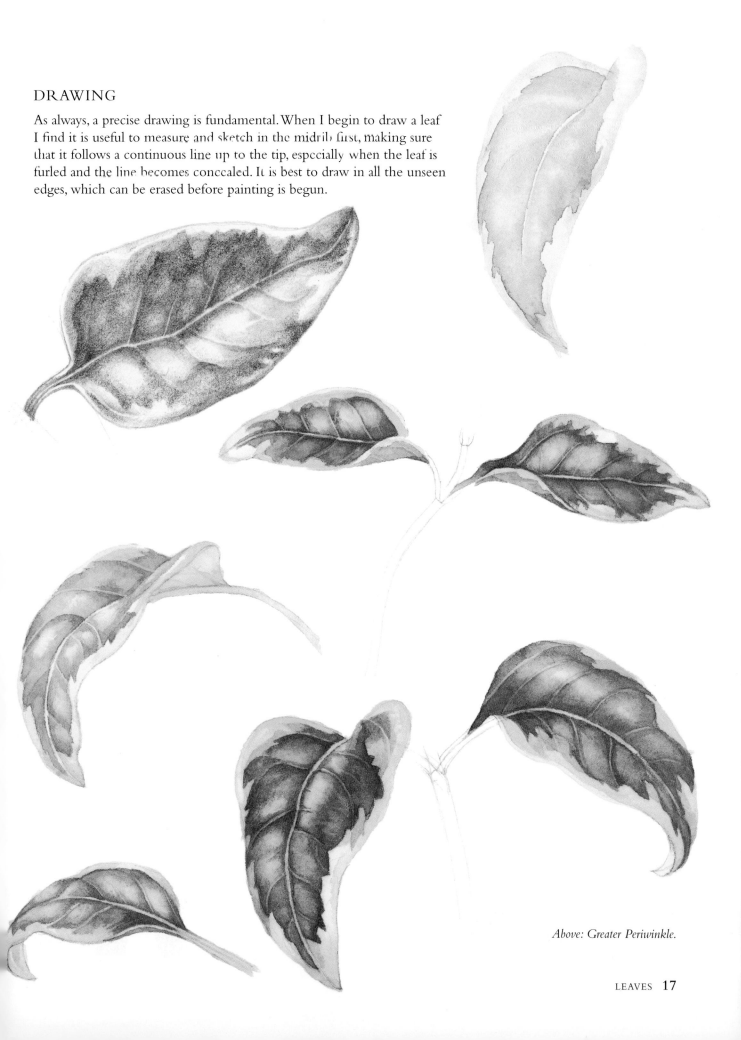

DRAWING

As always, a precise drawing is fundamental. When I begin to draw a leaf I find it is useful to measure and sketch in the midrib first, making sure that it follows a continuous line up to the tip, especially when the leaf is furled and the line becomes concealed. It is best to draw in all the unseen edges, which can be erased before painting is begun.

Above: Greater Periwinkle.

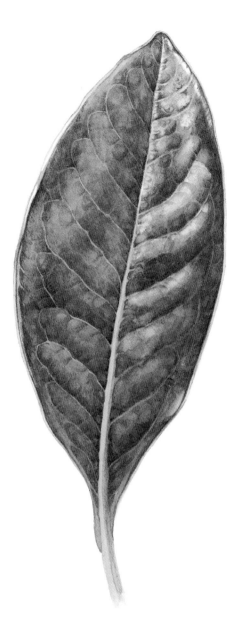

Above: Magnolia leaf.
Opposite page: Leaf studies. Clockwise from top left: magnolia, willow, greater periwinkle, berberis, hosta.

GERANIUM

After trying some leaves in my sketchbook I began to think about the assignment and to look for subjects that would make a satisfying composition as well as providing a variety of colour, shape and texture. My first choice was *Geranium × riversleaianum* 'Russell Prichard'. This lovely plant seeds itself all over my garden and flowers generously all summer. The palmate structure of the beautiful soft grey-green leaves was complicated to draw, so I used the midrib and main veins as guides to the position of the lobes.

I laid a first wash of Indanthrene Blue and Winsor Yellow, leaving some areas lighter where the leaf curved towards the light. Then I mapped out the minor veins with a finer brush and started to build up areas of colour between them, using feathery brushstrokes which I softened with a clean, damp brush. I noticed that the area of the stem attachment was a paler, more luminous green so I laid a wash of Sap Green and Winsor Yellow, softening it along the main veins into the bluer areas of the leaf. To strengthen shadow areas I mixed Payne's Grey and Sap Green. Finally I used opaque white body colour, or gouache, with a No. 0 brush to draw in the short hairs that cover the leaves. My tutor commented that I should have taken more care with this tiny but important detail, paying particular attention to showing the hairs as light against a dark background and dark against light.

MAGNOLIA

I thought that the leaf of *Magnolia grandiflora* would consolidate the composition, with its bold, simple shape. I planned to paint both the glossy dark green upper surface and the rust-red, suede-like indumentum on the underside. Using a strong mix of French Ultramarine and Aureolin with a touch of Alizarin Crimson, I laid a first wash, working on one half of the leaf at a time and taking care to leave the highlights untouched. When this was dry I changed to a finer brush and began modelling the areas around the main veins. As the large leaf looked flat at this stage, I tried to create more texture by working up the minor veins, but unfortunately the paper became overworked. Further attempts to add more washes into the shadow area made it muddy and tonal contrasts were lost.

HOSTA

To balance the magnolia leaves I chose the elegant variegated leaf of *Hosta fortunei*, with its undulating margins. The variegation presented me with a challenge, but I hoped that the strong lines of the veins would help me to maintain the structure. The leaf had three distinct areas of colour – creamy white, pale lemon-green and a mid-green that tended towards blue.

I began with a wash of Lemon Yellow with a touch of Indigo over the whole leaf, avoiding the white areas and the midrib. When it was dry I painted over the smaller area of mid-green, using a mix of French Ultramarine, Winsor Lemon and Neutral Tint, avoiding highlights which I planned to glaze over later with Cobalt Blue. Having completed this stage I began using a dry brush to model the areas between the veins, dragging the brush across in a horizontal movement to give texture. The tip of the

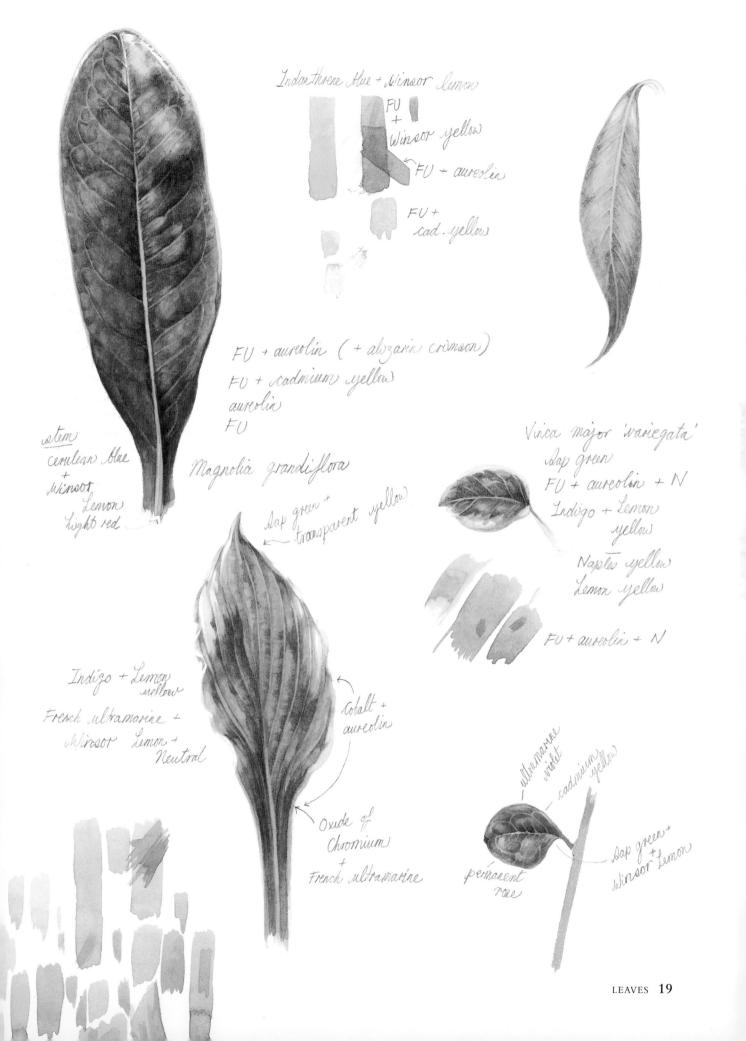

Indanthrene Blue + Winsor Lemon

FU
+
Winsor yellow

FU + aureolin

FU +
cad. yellow

FU + aureolin (+ alizarin crimson)
FU + cadmium yellow
aureolin
FU

stem
cerulean blue
+
Winsor
Lemon
light red

Magnolia grandiflora

Sap green +
transparent yellow

Vinca major 'variegata'
Sap green
FU + aureolin + N
Indigo + Lemon
yellow
Naples yellow
Lemon yellow

FU + aureolin + N

Indigo + Lemon
yellow

French ultramarine +
Winsor Lemon +
Neutral

Cobalt +
aureolin

Oxide of
Chromium
+
French ultramarine

ultramarine
violet

cadmium
yellow

permanent
rose

Sap green +
Winsor Lemon

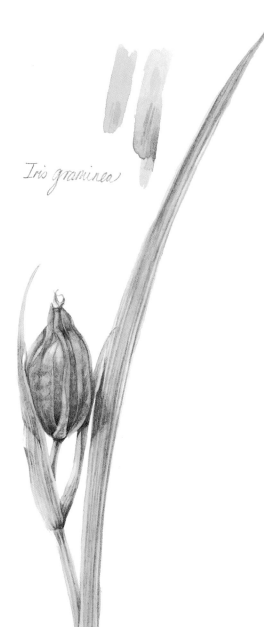

Iris graminea

leaf showed a brighter green, so I glazed over with a mix of Sap Green and Transparent Yellow which I painted down over the midrib. Finally I emphasized the undulating edges by strengthening the shadows with a 'botanical grey' mix of Light Red and French Ultramarine.

IRIS

To add a touch of drama I placed the long, curving iris leaf with its seedhead in the centre of the composition. The first wash consisted of French Ultramarine with Winsor Lemon on the main part of the stem. I left the highlights untouched and gradually faded out the paint as I pulled it down to the lower part of the leaf. Here a glaze of Cerulean Blue and Winsor Lemon was added later. Where a darker tone was needed to emphasize the curve of the leaf and the ribbed effect of the long parallel veins, I used a combination of Indigo and Indian Yellow.

OAK, HONEYSUCKLE, BERBERIS AND OLIVE

After painting the oak leaf with its sinuous form and the simple rounded shapes of the honeysuckle leaves, I looked for other, smaller leaves that would provide a variation of colour. I chose a purple-red *Berberis thunbergii* and silvery olive leaves, which are a slightly darker grey-green above and pale grey beneath. I used several combinations of colour to reproduce the subtle shades of grey, principally Terre Verte and Permanent Mauve, which make a really beautiful grey – although it is a bit sticky to handle, especially if one uses Winsor & Newton's Terre Verte. For the darker green on the upper surface I mixed Payne's Grey and Winsor Lemon.

TUTOR'S COMMENTS

Mary Ann received a disappointing mark for this lovely page of leaves and this could easily have been the point at which she gave up. Fortunately she contacted me and I reassessed her work to date. Assignment 1 was very fairly marked, but I had no doubt that the figure of 7.2 was too low for the page of leaves. I raised it to a more realistic 8.82 and, thankfully, Mary Ann decided to persevere. This situation rarely arises, but if there are any doubts I will always make amends as quickly as possible, sometimes in consultation with a colleague. In this case it appeared that her mark was low because she had used some white body colour for hairs and so forth. The English tradition of pure watercolour is to be encouraged, but there is no harm in the use of body colour, which would have been seen as normal by many of the masters from the past whom we try to emulate.

Above: Iris graminea seedhead.

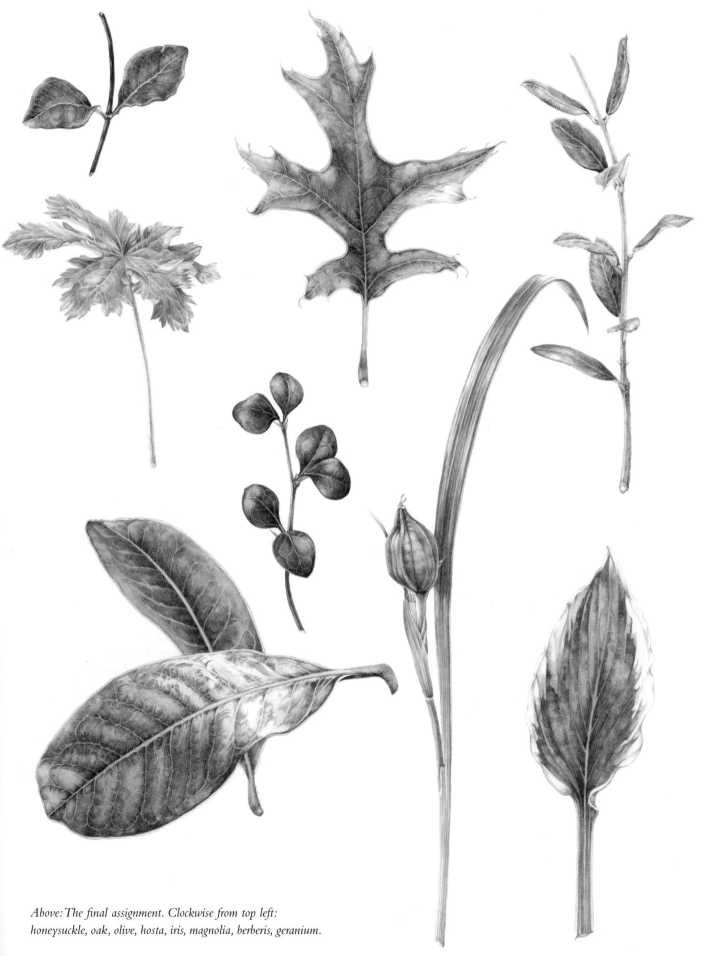

Above: The final assignment. Clockwise from top left:
honeysuckle, oak, olive, hosta, iris, magnolia, berberis, geranium.

ASSIGNMENT 3

Flowers

Margaret Stevens: *Colour comes into its own with this assignment, as the student is asked to produce a page of seven flowerheads. This gives the opportunity to choose a variety of shapes (seven members of the daisy family would not be welcome), colours and sizes, then arrange them on the paper to form a pleasing composition. The light source is important so that overlapping petals cast a realistic shadow on each other, or a central cluster of stamens may cast a shadow on the petals. This makes the flower look real and gives the illusion that it may be plucked from the page.*

The tutor will, of course, be looking for accuracy in the portrayal of each individual flower and also for harmonious colour and form, with the various sizes balanced as well as possible on the page.

Mary Ann Scott: Colour is an absorbing and personal subject. While I admire the discipline of painters who produce beautiful work from a few carefully chosen colours, I love poring over manufacturers' shade cards and experimenting with new pigments. We all seem to interpret colours differently and I find it useful to look at work by different artists to see the various ways in which they have dealt with it.

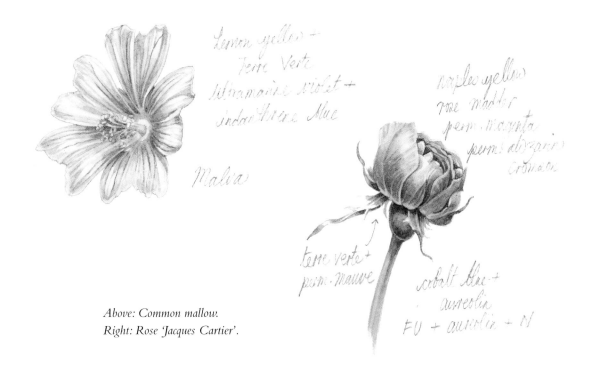

Above: Common mallow.
Right: Rose 'Jacques Cartier'.

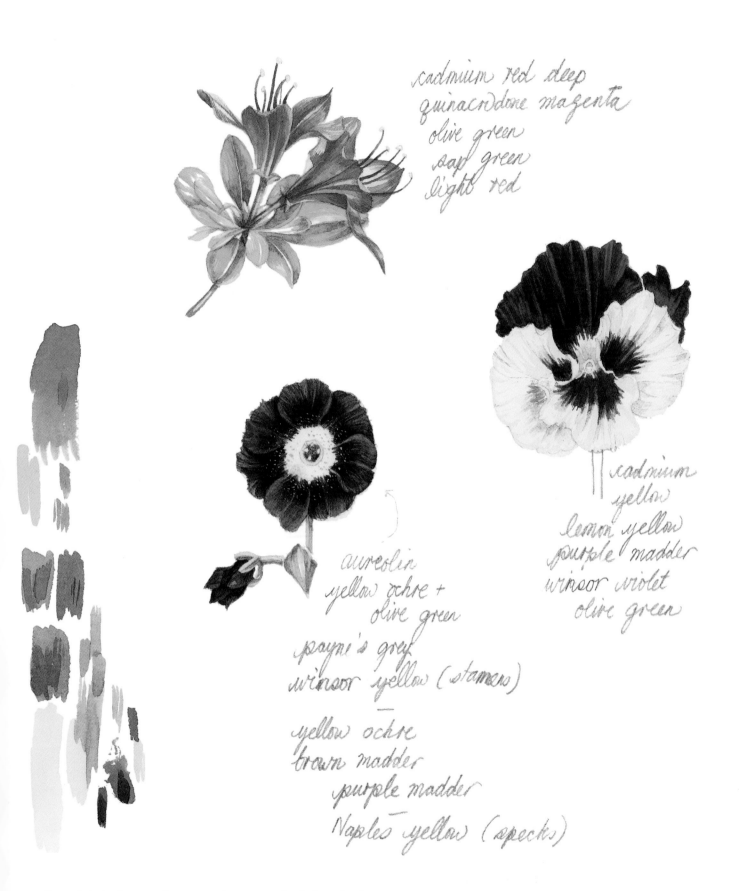

cadmium red deep
quinacridone magenta
olive green
sap green
light red

aureolin
yellow ochre +
 olive green
payne's grey
winsor yellow (stamens)

yellow ochre
brown madder
 purple madder
Naples yellow (specks)

cadmium
yellow
lemon yellow
purple madder
winsor violet
olive green

Above, clockwise from top: Japanese azalea, pansy, primula (reproduced from The Art of Botanical Painting; *see Bibliography, page 128).*

Above: Common mallow and honeysuckle.
Opposite page: Clematis 'Madame Julia
Correvon' and geranium 'Russell Prichard'.

THE EXERCISE

Before beginning work on the assignment, it was suggested that we try to reproduce some of the flowerheads illustrated in the chapter 'The Flower Library' in *The Art of Botanical Painting* (see Bibliography, page 128). This was a first step towards exploring the different shapes and colours of flowers. It was particularly useful because it opened my mind to different combinations of pigments and the way the colour could be built up in layers to suggest the underlying reflections in a petal.

HONEYSUCKLE PENCIL STUDY

August is hot and humid in the north of Italy. Most of the inhabitants of the towns flee to the seaside or the mountains for their holidays, while the countryside at home shrivels up and gardens droop wearily in the heat. Searching for flowers to paint during this period was a frustrating business, with every nursery and florist displaying a sign saying *chiuso per ferie* (closed for holidays) on locked doors.

A honeysuckle was still flowering courageously in my garden. The complicated pattern of twisting peduncles was daunting, so I decided to start with a pencil study which would help me understand the structure and tone without worrying about colour.

CLEMATIS

In my garden *Clematis viticella* scrambles through a holly bush. The flowers, which are produced late into the summer, have four petals of a velvet ruby-red, and I began these with a first wash of Permanent Alizarin Crimson which I faded towards the base of the petal, then painted over with a mix of Ultramarine Violet and French Ultramarine. I continued intensifying the red colour with more Alizarin Crimson mixed with Thioindigo Violet, paying attention to the ribbed structure and the fall of the light on the twisted, recurved petals. The red pigments were looking flat, so I glazed over a wash of Quinacridone Red and then more Alizarin Crimson to strengthen the tones. The shadows were deepened with Purple Madder, and further with a mix of Purple Madder and Neutral (see page 127) in the darkest areas. As the petals were quite thick and opaque, I was not afraid to build up several layers of colour and work into the details.

GERANIUM

The flower of *Geranium* × *riversleaianum* 'Russell Prichard' was a complete contrast to that of *Clematis viticella*; its small, notched petals seemed fragile and transparent in comparison with the thick, velvety clematis petals. The colour was a delicate pink, verging towards magenta, fading to greenish white towards the base, with a pattern of darker veins. It was tricky to find a match for this but after much experimentation I settled for a mix of Rose Madder and Ultramarine Violet. I worked hard on this apparently simple bloom, but found it difficult to give it form and structure without spoiling the delicacy of the petals. Ultimately I decided that it required a more experienced hand than mine.

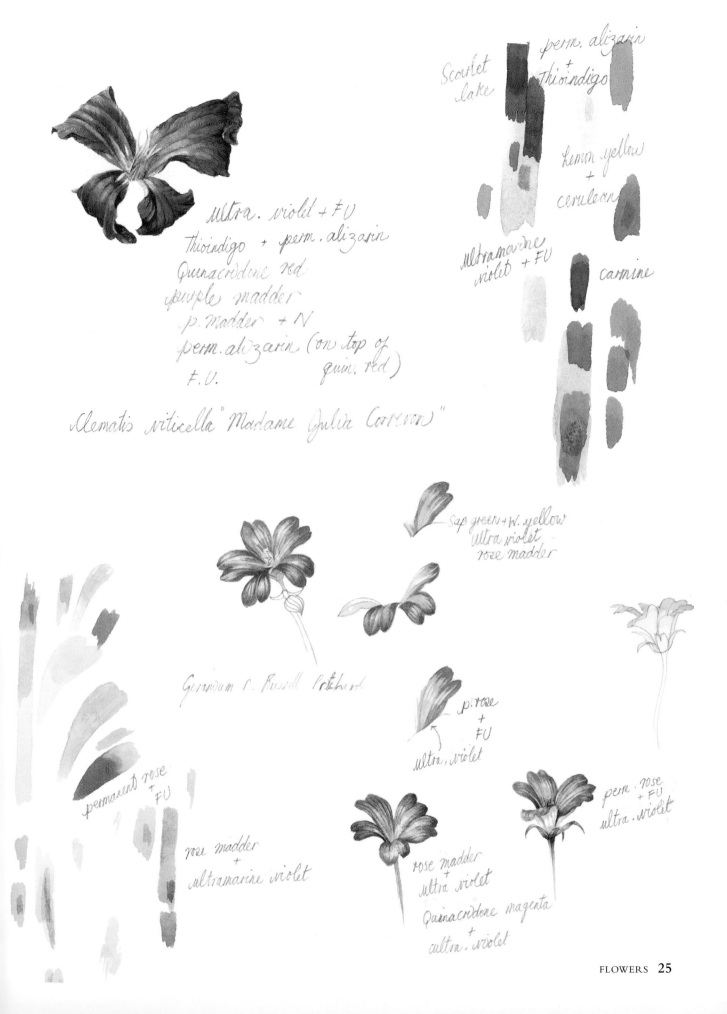

ultra. violet + FU
thioindigo + perm. alizarin
Quinacridone red
purple madder
p. madder + N
perm. alizarin (on top of
 F.U. quin. red)

Clematis viticella "Madame Julia Correvon"

Scarlet lake

perm. alizarin
+
Thioindigo

Lemon yellow
+
cerulean

ultramarine violet + FU

carmine

sap green + W. yellow
ultra violet
rose madder

Geranium r. Russell Pritchard

permanent rose + FU

p. rose
+
FU
ultra. violet

rose madder
+
ultramarine violet

rose madder
+
ultra violet

Quinacridone magenta
ultra. violet

perm. rose
+ FU
ultra. violet

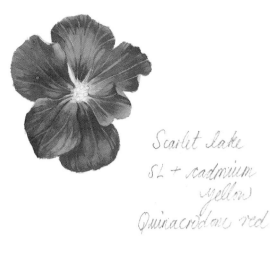

Scarlet Lake
SL + cadmium
yellow
Quinacridone red

PELARGONIUM AND FUCHSIA

I could not resist the challenge of trying to catch the vibrant scarlet of this pelargonium. I built up layers of Scarlet Lake, glazing over with Cadmium Yellow where the petals curved towards the light and showed a warmer red, and adding Alizarin Crimson where a deeper tone was needed. Finally I glazed over the highlights with Quinacridone Red to intensify the reds.

Reproducing the intense reds of some flowers can be quite difficult because the paint tends to lose much of its brilliance when it dries on the paper. However, with so many red pigments available, it is fun to try to capture those glowing hues.

The fuchsia was enjoyable to paint, with its simple bell-shaped structure and the interesting contrast between the sepals and inner petals. I tried to show the thickness and waxy texture of the sepals, which I painted with glazes of Quinacridone Red, Scarlet Lake and Permanent Alizarin, with French Ultramarine added in the shadows. I used Winsor Violet for the petals, glazing over the highlights with Quinacridone Red.

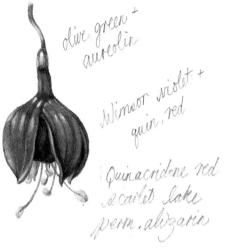

olive green +
aureolin

Winsor violet +
quin. red

Quinacridone red
scarlet lake
perm. alizarin

LILIES

I was looking for some larger flowers to fill my page and decided to try some lilies, which attracted me with their simple sculptural shapes. The yellow lily looked invitingly fresh despite the August heatwave and would contrast well with the reds and the violet Malva. The difficulty of yellow

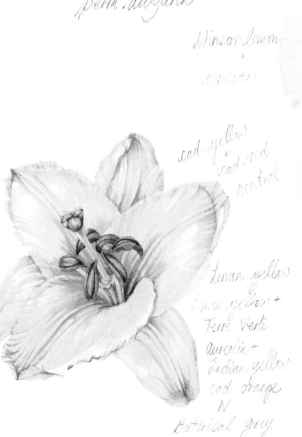

Winsor lemon
+
cerulean

cad. yellow +
cad. red
neutral

Lemon yellow
lemon yellow +
Terre Verte
aureolin +
Indian yellow
cad. orange
N
Botanical grey

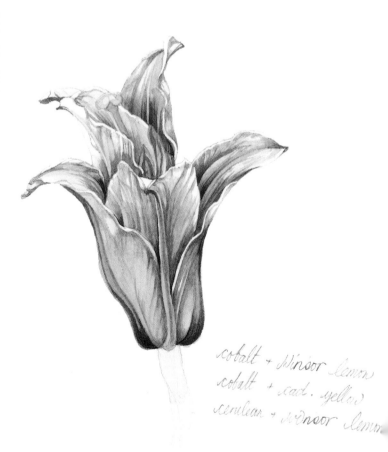

cobalt + Winsor lemon
cobalt + cad. yellow
cerulean + Winsor lemon

lies in finding the right shadow colour and in not overdoing the shading, or it may easily become muddy. It is important to observe whether the yellow tends towards the cooler or warmer end of the spectrum, and correspondingly choose tints that may be greenish-grey, for example, or alternatively contain a touch of violet or a warmer ochre. I started with a wash of Lemon Yellow, leaving plenty of white paper for the highlights. When this was dry I began shaping the petals with a cool mix of Lemon Yellow and Terre Verte, trying not to overdo the shading at this stage. I used a mix of Aureolin and Indian Yellow to show the deeper yellow that appeared at the base of the petals, and finally I used a 'botanical grey' mix of French Ultramarine and Light Red where I thought the shading needed more emphasis. The stamens were painted with an orange made up of Cadmium Yellow and Cadmium Red, to which I added Neutral Tint for the shadows.

When I had completed the lily I began looking around for another flower with warmer hues to balance the pinks, reds and blues. While exploring the dusty corners of a garden centre I came across an orange Rudbeckia and hurried to paint its one remaining bloom without any preliminary sketches.

Opposite page, from top: Pelargonium, fuchsia, lily, stargazer lily.
Below and right: Hosta.

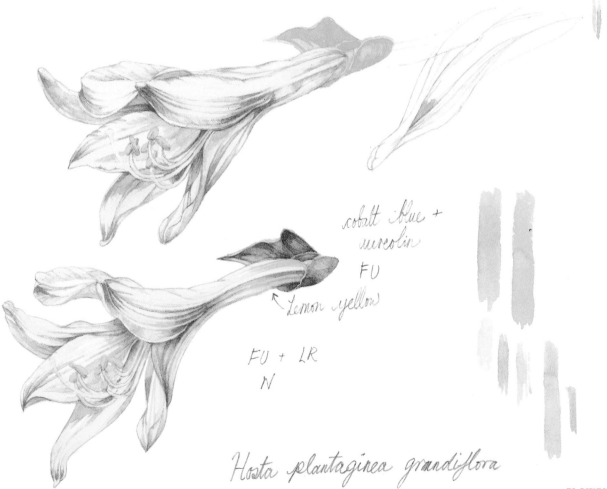

cobalt blue +
aureolin

FU

Lemon yellow

FU + LR

N

Hosta plantaginea grandiflora

HOSTA

I wanted to try to paint this pristine flower, although I knew it would be difficult on a white background and without the possibility of using the leaves to emphasize its whiteness. I studied the flower carefully, looking for the smallest reflections of coloured light that could help to give life to the painting. At this stage, it would have been useful to make a tonal study in pencil, which would have helped me to understand the minimum amount of shading I would need to render the form. However, I was impatient to begin and I mixed a weak wash of French Ultramarine and Light Red and began working up the shadows. I noticed a flush of light lemon-green at the base of the petals, and other slight reflections of yellow and blue.

A white flower requires a lot of thought and self-control; it is tempting to add small details here and there but easy to end up with a grey rather than white flower. I quickly learned that trying to correct mistakes with opaque white paint only muddied the painting even more, as did attempts to lift the colour with a damp brush.

CLEMATIS

Clematis × durandii is an intense metallic blue; on a sunny day the petals seem to shimmer like the wings of a butterfly. The flower is described as deep violet-blue, but I could see reflections of cerulean and cobalt. I also noticed shades of violet in the undulate margins. Eventually, after experimenting with different combinations, I decided that the dominant colour was Cobalt Blue and I painted this on as a first wash. When this was dry I started to build up the ribbed structure and the shadows in the margins with a darker mix of Cobalt Blue and Permanent Mauve. Lighter reflections were suggested with thin glazes of Permanent Rose, and the blue at the base of the petals was intensified using French Ultramarine. Finally, I added the deepest shadow tones with a mix of Cobalt, Permanent Mauve and Neutral (see page 127).

When I was satisfied with my preliminary sketches, I began painting each flower onto the page, one by one. I was so preoccupied with colour and the problems of showing the shape and texture of the petals that I hardly spared a thought for the composition.

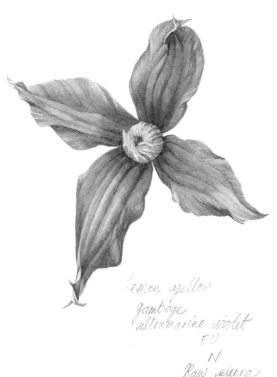

TUTOR'S COMMENTS

The composition rather spoiled the finished assignment and this, coupled with the very grey hosta flower, brought Mary Ann's mark down again to 80 per cent.
It would be quite difficult to make a good composition out of four larger flowers and three smaller ones. Had the ratio been 5:2, it would have worked out more successfully. The hosta, pristine white, could have formed the apex at the centre top, with the two smaller flowers on either side and slightly lower. The rudbeckia and clematis could have formed the middle tier, and the lily, with another flower of equal size, would have added weight to the bottom. Either that or Mary Ann might have painted an extra flower level with the rudbeckia and left the rest unchanged.

Above: Clematis.
Opposite page: The final assignment.
Clockwise from top left: Clematis, mallow, fuchsia, hosta, clematis, rudbeckia, lily.

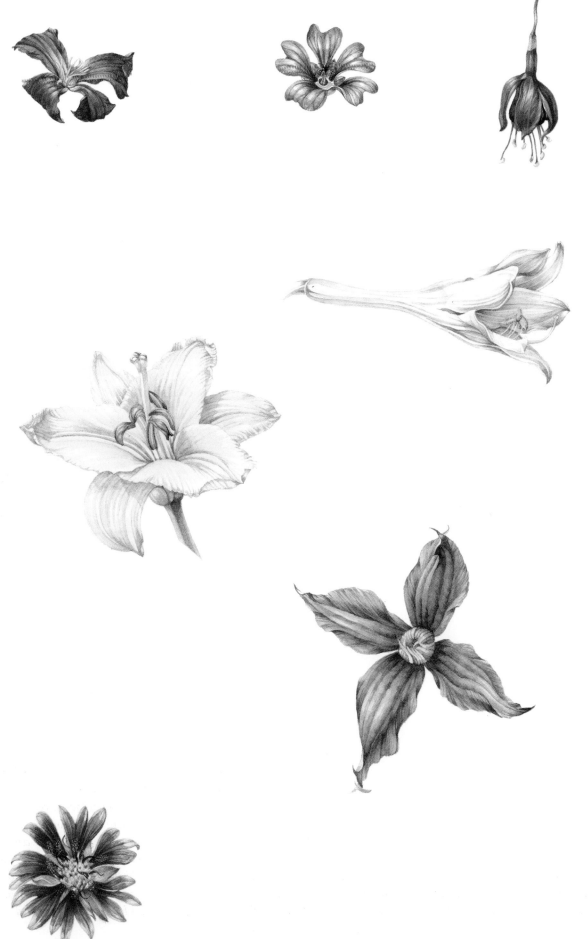

ASSIGNMENT 4

Single Flower Study

Margaret Stevens: *In Assignment 4 we want to see the various elements brought together in a single-variety study showing leaves, flowers and stems. This calls for sharp observation as the tutor will be looking for details such as accuracy in describing the leaf joints and the stem, which can be round, square, ridged, variable in width and smooth or hirsute.*

Naturally there is a huge range of flowers from which to choose but students are sometimes at a loss, perhaps because there is so much available. A regular question is 'Does it need to be just one flower?' to which I reply, 'It depends entirely on the flower.' One beautiful rose with its bud and leaves in the style of Redouté is suitable, but so too is a cluster of rambling roses. A single incurved chrysanthemum flowerhead may be someone's preference to a stem of spray chrysanthemums, but some genera, for example daffodils, look better in an odd-numbered group rather than as a single stem.

Mary Ann Scott: Although we were always encouraged to place the leaves and flowers on the paper in a pleasing and interesting way, the emphasis of the two previous assignments had been more on technique and accuracy of colour than composition. Now we were being asked to pay more attention to the balance of shapes, colours and tone, to the empty spaces between shapes and to the habit of growth. All these elements should combine to lead the eye into the painting and to give the impression of a living plant rather than a mechanical representation.

Right: Gladiolus bud.
Opposite page: Gladiolus and Peruvian lily.

GLADIOLUS

After completing the flower page for the previous
assignment I felt dissatisfied with the results of my
efforts. My flowers and leaves looked overworked;
all the detail seemed to distract the eye rather than
enhance the form. I wanted to be able to depict
variations of hue and tone in a softer, more unified way,
and I thought that by trying to improve my technique of
wet-into-wet I would be heading in the right direction.

A spray of *Gladiolus* provided a fine subject to practise
on, with its flounced petals and succession of hues from the
lime-green buds to the warm yellow of the opened blooms.
The half-open bud of a purple gladiolus was also fun to work
on. I enjoyed showing the papery texture of the sepals and the
way they enclosed the emerging petals with hints of violet
showing through the layers of pale green.

ALSTROEMERIA

I was attracted to the soft pinks and yellows of a small bunch of
Alstroemeria (Peruvian Lily) I saw in the supermarket. A quick
sketch gave me the opportunity to practise blending a mix of
Permanent Rose and Cadmium Yellow into Cadmium Pale.
When this was dry I painted in the characteristic spotting on
the petals with a finer brush.

cerulean + cad. lemon
+ N

permanent
rose
+
cad.
lemon

Lemon yellow
Cad. Lemon
cad yellow
Indian yellow
cerulean

ANEMONE

I love *Anemone × hybrida* 'Honorine Jobert'. Not only does it grow readily on my clay soil, but its beautiful flowers seem to herald the first bright autumn days and cool breezes after the long, hazy summer. It seemed an obvious choice for the assignment, especially since I usually prefer painting flowers I grow myself – apart from the affection and familiarity engendered by nursing them into maturity in sometimes arduous conditions, there is abundant material to hand.

I began making small studies of the open flowers, the buds and the smaller immature leaves at the base of the flower stems. I thought the anemone would make an interesting composition with its large, dark

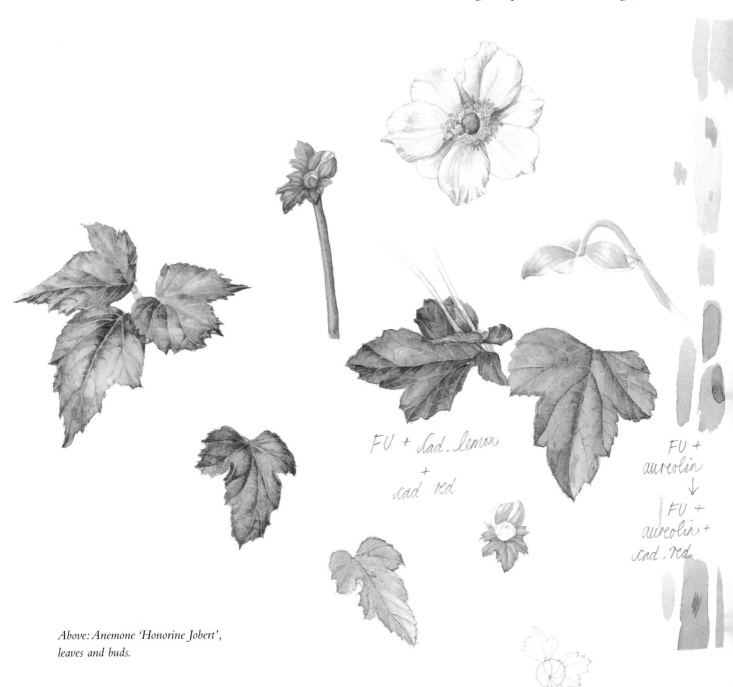

Above: Anemone 'Honorine Jobert', leaves and buds.

green leaves and pure white flowers with yellow centres. I liked the stiff, wiry stems and the way they branched like candelabra, carrying a multitude of buds.

After working on the sketches for some time, I reluctantly decided that the anemone was too much of a challenge. The leaves were complex and there was the perennial problem of painting white on white, requiring skill and precision. At this stage in the course I hoped to paint an assignment that would raise my marks and my morale, and while the anemones were delicate and beautiful, I wanted a subject that would have greater impact on the white paper.

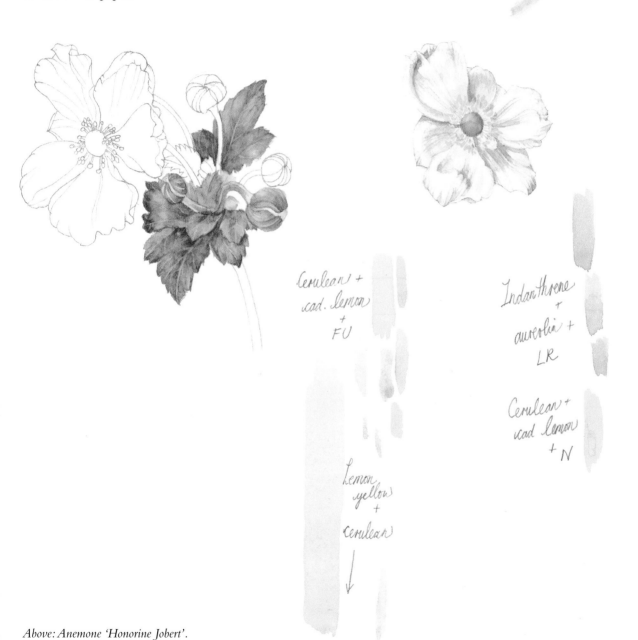

Cerulean + cad. lemon + FU

Indanthrene + aureolin + LR

Cerulean + cad lemon + N

Lemon yellow + cerulean

Above: Anemone 'Honorine Jobert'.

Below and opposite page: Dahlia 'Bishop of Llandaff'.

DAHLIA

Dahlia 'Bishop of Llandaff', with its deep red flowers, purple stems and bronze-green leaves, certainly had impact. It was growing in a pot, which was a great advantage as I knew it would require quite a long time to finish the work from the moment I began with preparatory sketches to the completion of the assignment. Moreover, the plant was a sturdy specimen that showed different stages of growth, so I was able to observe the variations of green in the mature and immature leaves, for example.

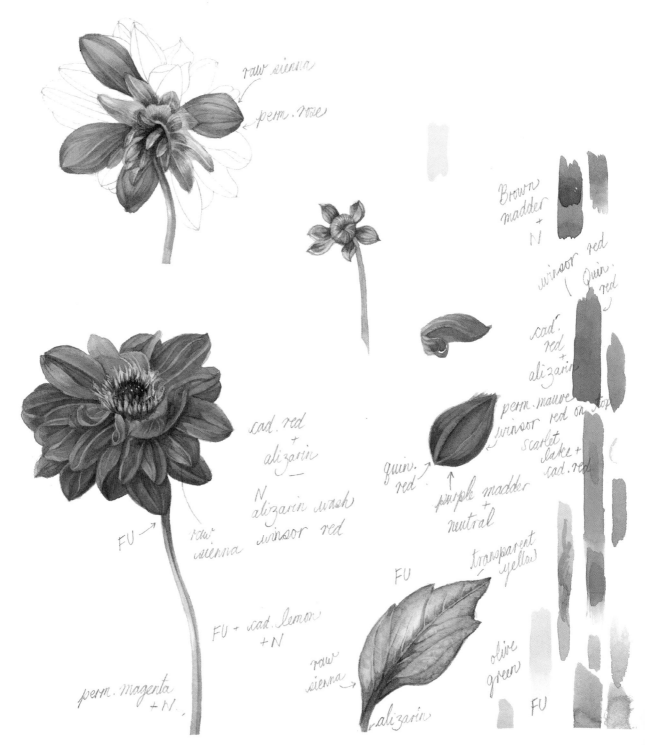

raw sienna

perm. rose

Brown madder + N

winsor red

Quin. red

cad. red + alizarin

perm. mauve

winsor red on top

scarlet lake + cad. red

cad. red + alizarin

N alizarin wash winsor red

quin. red

purple madder + neutral

FU

transparent yellow

FU

raw sienna

olive green

FU

raw sienna winsor red

FU + cad. lemon + N

raw sienna

alizarin

perm. magenta + N.

After making a sketch of an open flower I was relieved to find that the bloom remained quite motionless over the period of time it took me to paint it. Working on single petals, I began experimenting with different combinations of pigments to try to catch the luminous quality of the reds. I settled for a basic mix of Alizarin Crimson and Cadmium Red and a mix of Purple Madder and Neutral in the shadows. I noticed a more brilliant red hue where the light shone through the petals, and glazed over with a wash of Winsor Red. Finally, when the paint was dry, I laid a watery glaze of Permanent Rose over all the petals to unify and soften the details.

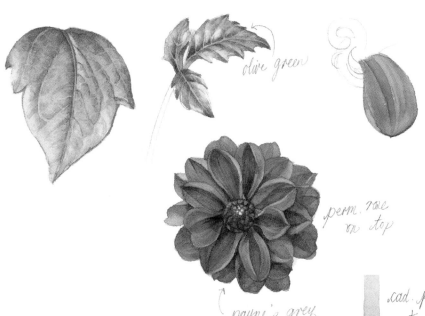

olive green

perm. rose on top

payne's grey

cad. lemon + N

↓

alizarin

Brown madder + perm. alizarin

perm. magenta + N

carmine + payne's grey

cad. pale + cerulean + cad. red + FU

alizarin + cad. red

FU + cad. lemon + N

FU + cad. lemon + N

purple madder + N

oxide + alizarin

FU + cad. lemon + LR.

PLANNING THE COMPOSITION

For my last assignment the tactful comment of my tutor had been 'the composition could be more interesting'. Now I was determined to make much more effort, and once I was satisfied that I had understood the main structures of the flowers and leaves I started to plan the composition using rough pencil sketches. While I did so I tried to bear in mind some important basic principles such as the use of triangular shapes and an odd number of blooms.

Looking at work by artists I admired, I could see that composition was a very personal matter, like colour. Whatever the choice, whether traditional or innovative, it was important to fit the style of the composition to the shape and habit of the flower. An interesting and pleasing composition would arouse the curiosity of the viewer and encourage him or her to look more closely, while a clever arrangement of shapes and colours would lead the eye from one detail to another.

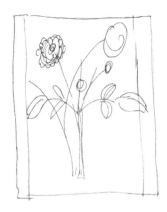

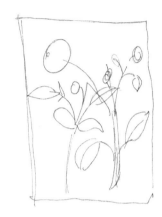

THE ASSIGNMENT

I decided to plan my composition around a strong central stem bearing two fully opened flowers, one bending forward, the other viewed from behind, leading the eye 'out' of the picture. This would also enable me to show details of the stem attachment and the paler colour of the petals' underside. On the right, another stem held an open flower, viewed from a different angle, and on the left another stem with closed buds and immature leaves balanced this simple composition.

I began by lightly sketching in the main structures, concentrating on the three open flowers and the leaves on the main stem. I knew the painting would take me a long time and I planned to complete the flowers first, before they had a chance to wilt. Then I would work on the leaves, leaving the stems until last. This was not an unreasonable scheme, but unfortunately I became so focused on the flowers and leaves that I neglected the stems and thereby wasted a lot of the work that I had put into the rest of the painting. Correctly drawn and well-painted stems are an important element in the composition. They can contribute to the flow of the painting, like strings tying the different components together.

My tutor's detailed and very helpful comments paid particular attention to the stem problem. For example, she pointed out that if the stem on the right-hand flower had been slender and bowing the other way, mirroring the curve of the left-hand flower, more harmonious spaces would have been created and more depth, as the eye would have been carried away, along the curve. She also noted that not only did the stems look stiff and unconvincing but their diameters fluctuated in a peculiar way. I had wanted to portray the leaf joints and texture of the stems accurately, but I had neglected careful measurement of the stem width.

I enjoyed painting the rich, warm red of the petals, but by continuing to build layers of colour I lost some of the highlights and tonal contrast which would have given more depth to the flowers. I was not paying enough attention to the light source either, and this resulted in some strange, inappropriate shadows.

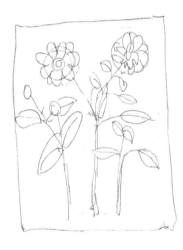

TUTOR'S COMMENTS

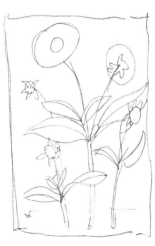

The last assignment seemed to inspire Mary Ann and she made a huge effort to impress her tutor, this time Brigitte E. M. Daniel, who apart from being a brilliant artist is an exceptional tutor. Brigitte wants to draw out the very best from her students and rarely gives high marks, so the 82 per cent awarded for this painting was praiseworthy. The flowers have lost their brilliance and the stems are not particularly elegant, but the colour is excellent and the leaves, never easy to capture on 'Bishop of Llandaff', are beautiful. Their metallic quality really responds to the light and the specimen needs careful positioning to show this to the best advantage.

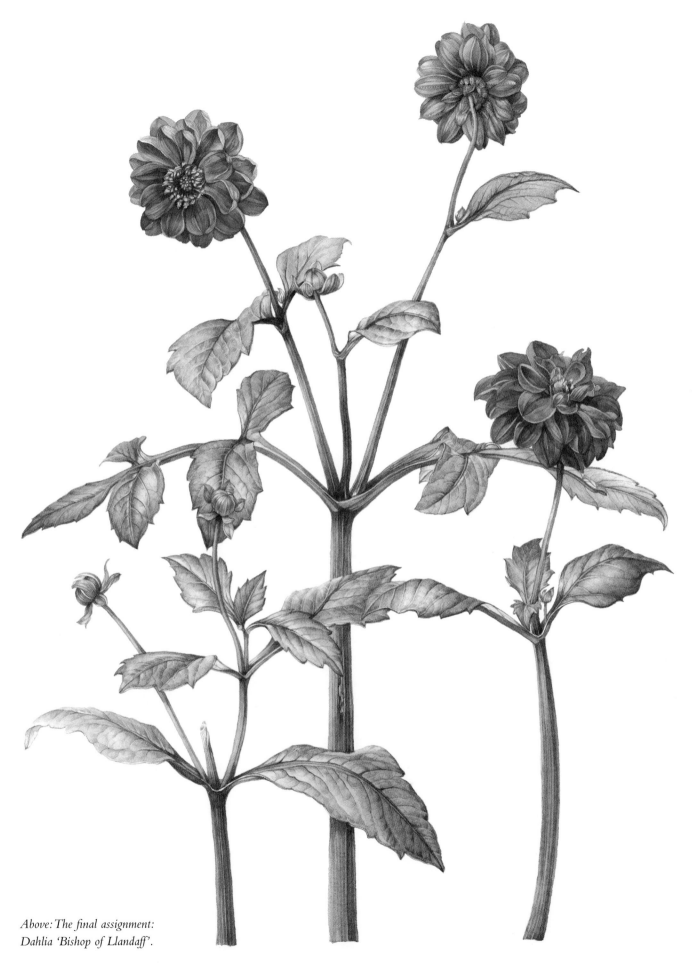

Above: The final assignment:
Dahlia 'Bishop of Llandaff'.

ASSIGNMENT 5

Fruit

Margaret Stevens: *I am sure that many students breathe a sigh of relief when they come to this assignment. For the first time, they have the option to paint something less transient than flowers and leaves. Unless they choose soft fruit such as raspberries, which might turn mouldy in the time it takes to capture their intricate structure, this assignment is very straightforward – or is it?*

The solid forms of apples, pears or persimmons need to display perfect variation in tone if they are to look three-dimensional. The artist wants the viewer to feel that he or she can pick the fruit off the page. Outstanding painters from the past such as William Hooker and Mrs Augusta Withers not only achieved this but also created an illusion of texture, succulence or crispness. The tutors look out for some degree of these elements.

Mary Ann Scott: Before beginning the assignment we were encouraged to look at the ways other artists had approached the subject and to carry out an exercise designed to improve wet-into-wet techniques. This also focused awareness on the light source and the disappearing edge where the fruit curves away from the light.

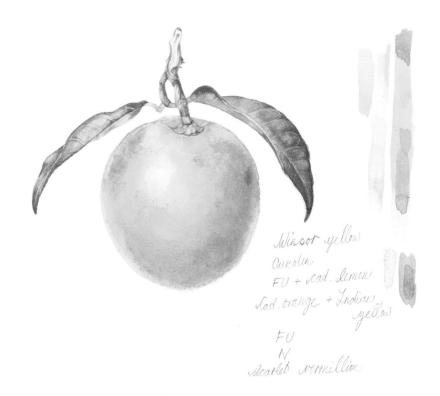

Above: Orange. Opposite page: Persimmons, birch leaves and figs.

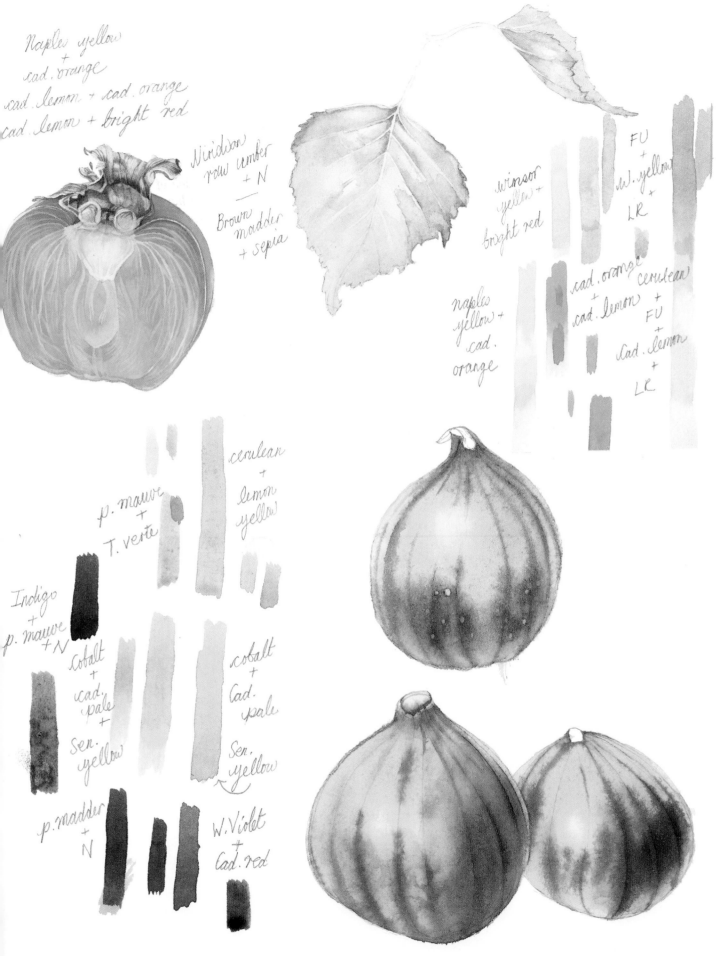

Naples yellow
+
cad. orange
cad. lemon + cad. orange
cad. lemon + bright red

Viridian
raw umber
+ N
—
Brown
madder
+ sepia

winsor
yellow +
bright red

FU
+
W. yellow
+
LR

naples
yellow +
cad.
orange

cad. orange
+
cad. lemon

cerulean
+
FU
+
Cad. lemon
+
LR

p. mauve
+
T. verte

cerulean
+
lemon
yellow

Indigo
+
p. mauve
+ N

Cobalt
+
cad.
pale
+
Sen.
yellow

cobalt
+
Cad.
pale
+
Sen.
yellow

p. madder
+
N

W. Violet
+
Cad. red

THE EXERCISE

I began by drawing a series of circles, using the same watercolour paper on which I would later paint the finished picture, as this helps me to understand how the paint will react. I then mixed three yellow washes, increasing the pigment strength in each, and laid the palest wash evenly over the circle. While this was still damp I laid the middle tone, imagining a light source from the upper left corner. I tried to prevent the paint reaching the edge. The third wash was applied in the same manner. Speed was essential to prevent the paint drying and the formation of tidemarks. When I felt confident I repeated the sequence, this time using washes of yellow, rosy red and a deeper crimson.

This apparently simple exercise enabled me to appreciate how the paint behaved when I dropped it in, allowed it to spread and, if necessary, lifted off the excess with a clean, damp brush. The wetness of the paper is also important and I find that by holding it up to the light I can judge whether or not the water has spread evenly before putting on the pigment.

Another valuable lesson I had to learn was to resist fiddling. You need to be disciplined and decide to leave something alone, waiting until a wash is completely dry, if a correction needs to be made and more paint added.

APPLES

Below: Annurca apples.
Opposite page: Williams pears and Victoria grapes.

I worked on the exercises until I felt confident enough to start on some real fruit, beginning with the Annurca apples. After wetting the paper I applied a wash of Cadmium Red and Alizarin Crimson, taking care to avoid the highlights and edges, as I intended to add diluted transparent washes of Quinacridone Red towards the light and a colder blue or violet colour where the edge receded on the opposite side.

Waiting for the paper to dry after each application, I continued to build up the colour until I was satisfied with the tones. I started to strengthen the shadows with a mix of Purple Madder and Neutral Tint before adding texture with a dry brush, using Alizarin Crimson.

Once I was satisfied that I could do no more to give form and texture without muddying the paint, I set about livening up the initial Cadmium Red and crimson colours with light washes of Quinacridone Red, Scarlet Lake and Raw Sienna.

PEARS AND GRAPES

I wanted to depict the chunkiness of the pears and, employing the same techniques, painted them using Yellow Ochre, Brown Madder and Raw Umber with flushes of Scarlet Lake and Viridian. I tried to capture their delicate shading while still suggesting their weight in the hand.

The grapes provided a different challenge, with the transparency of their skins and delicate variations of colour from pale lemon green to ripening, warmer shades. I tried to reproduce the bloom with an initial pale wash of Viridian.

cad. pale
+
cerulean
+
FU

raw sienna

cad. lemon
+
cerulean
+
FU

caput mort. violet
+
Brown madder

viridian

Williams Pear

cad pale
+
cerulean
+
LR

viridian
cad. lemon + cerulean
+ LR
N

cad. pale
FU
sap green

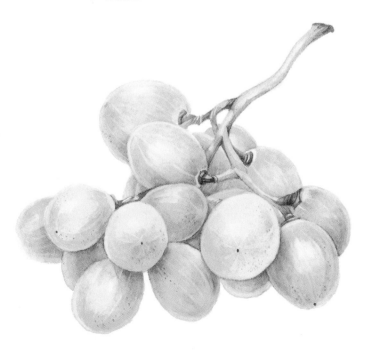

THE ASSIGNMENT

Now it was time to start the finished assignment. I felt I had fussed too much over the composition of the previous flower study, so this time I would aim for simplicity with strong simple shapes. On a foggy November day I headed for the market, and in particular Daria D'Accunta's stall, where I buy organic fruit and vegetables on a Saturday morning. Spotting a mound of persimmons, I decided these would be an excellent choice with their rich, warm colours and crisp, curving sepals. While they are native to Japan and China, they are commonly cultivated in Piedmont, where I live. They are often grown against the stone walls of old farmhouses, where in late autumn the fruit are left to hang on the bare branches, looking like strange Christmas decorations.

In my previous assignment my painting had been justifiably criticized for showing an 'epidemic of poorly painted edges', so now I was determined not to repeat the mistake. My persimmons would look fat and ripe, not woolly! I aimed for a composition that would emphasize the round shapes, superimposing them to bring out the light on the disappearing edges. By turning the fruit to face in different directions I would add interest, depth and tone. Observing them carefully, I could see that the basic orange colour changed from lemon yellow towards pink and red as the fruit ripened.

With mixes of Cadmium Orange and Cadmium Lemon I achieved a cooler, 'unripe' orange, whereas Cadmium Orange and Bright Red made a strong, deep colour that covered well. I started to build up layers of strong washes, as I wanted to achieve a rich, deep tone without losing any brightness and clarity.

It is not easy to find a shadow colour for orange but I found that, as with yellow, variations of mauve and violet worked well. The lighter

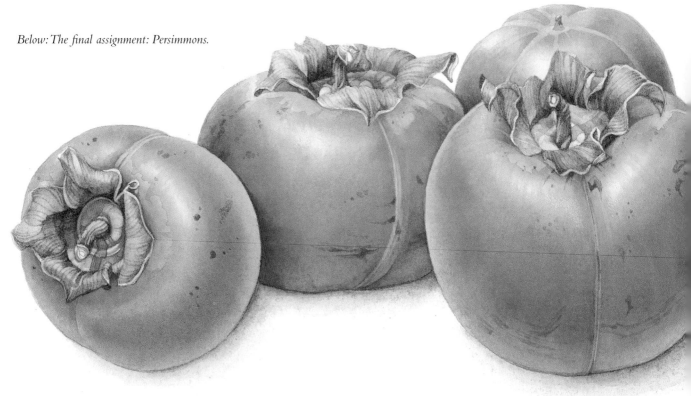

Below: The final assignment: Persimmons.

edges of the fruit needed to be slightly darker than the highlights, so I applied a light wash of Permanent Rose which showed up well against the shadow of the fruit behind. I also noticed a beautiful intense pink underneath the sepals, which I accentuated with a wash of Scarlet Lake.

I was careful not to overwork the smooth, shiny skin and added a minimum of the tiny blackish-brown spots and scars that appear as the fruit ripens. In my trial studies I had reproduced these faithfully, but felt my painting looked overcrowded, so this time I added just a few of these imperfections, placing them in patterns that emphasized the roundness of the fruit.

Above: Persimmons (black-and-white photocopy).

TUTOR'S COMMENTS

Painting shadows beneath fruit or vegetables tends to turn the picture into a still life and they are unnecessary for a botanical study. As their inclusion can spoil an otherwise good painting, students are told not to paint any shadows other than cast shadows on the actual objects. However, in Mary Ann's case they did not detract from a beautifully worked assignment and her tutor gave a well-deserved mark of 9.4.

There is no better way to check the tonal values of your painting than by taking a black and white photocopy. Without the distraction of colour, the form of the subject is clearly seen from lightest to darkest tones. A photocopy of another persimmon study (above right) demonstrates this to perfection.

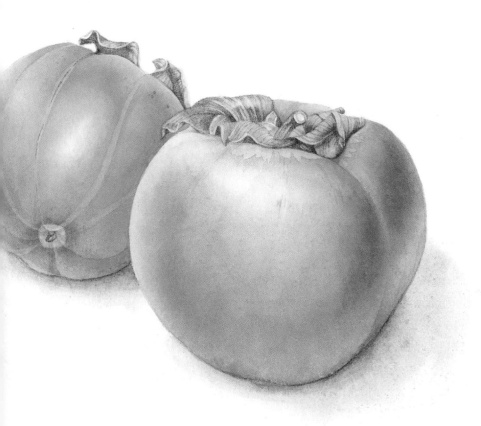

ASSIGNMENT 6
Vegetables

Margaret Stevens: *For this assignment we bend the rules somewhat. Just as supermarkets display tomatoes – a fruit – alongside vegetables, and rhubarb in the fruit section when it is in fact a vegetable, so we allow a certain cross-over and no marks are lost for these ambiguities.*

For the first time there is the opportunity to apply larger areas of wash, as no right-minded person is going to attempt a swede using a dry No. 2 brush. This is really quite a fun assignment as students discover the shapes and shades of potatoes, the feathery foliage of carrots or the ever-popular jewel-like gloss of a perfect red onion. Beauty becomes apparent in the everyday familiarity of mundane ingredients for a stew or the salad bowl. A Little Gem lettuce cut in half displays all the intricacies of its lines and delicate folds, not to mention the freshest shades of green that anyone could wish for. Tutors will appreciate a parsnip or carrot as much as a cabbage, as long as they both look realistically edible.

Mary Ann Scott: I had enjoyed painting the fruit and my good mark had been most encouraging. I have always been fascinated by the subtle colours and varieties of shape and texture that can be found among the piles of vegetables on display in the shops, so I felt enthusiastic about undertaking this new assignment.

Above: Black-and-white photocopy of a tomato, with the original painting.

TOMATO

I wanted to consolidate and build on the techniques I had learned in the previous assignment, and my first choice of subject was similar in form and texture to the persimmons. Again I was able to practise laying a succession of glazes to try to capture the intense red of the ripe tomato.

ARTICHOKES

Late winter is the season when artichokes rule! A glance at any market stall will show a multitude of varieties, from the Tuscan Violetta to the Roman Mammolo and the Spinoso from Sardinia, which has bracts tipped with vicious-looking claws.

I was becoming interested in the idea of a composition showing several varieties of artichoke arranged at different angles, so with this in mind I began a study of a Violetta lying sideways so as to show the heavily ribbed stalk. When I had drawn the outline I decided to treat each bract as a separate leaf rather than laying a first wash over the whole shape. The dominant colour was a subdued mauve which merged into a bluish-green towards the base. I noticed a touch of a yellower green at the tip where the small spur emerged. I began to lay washes of Thioindigo Violet mixed with Neutral which I merged with a mix of Hooker's Green, French Ultramarine and Neutral (see page 127) while the paper was still damp. More Neutral was added to the mixes to darken the shadow areas. I wanted to show the thick, fleshy texture of the bracts and when the paper was dry I began working up the surface detail. Finally I glazed over some areas where the light reflected on the violet with a little Alizarin Crimson.

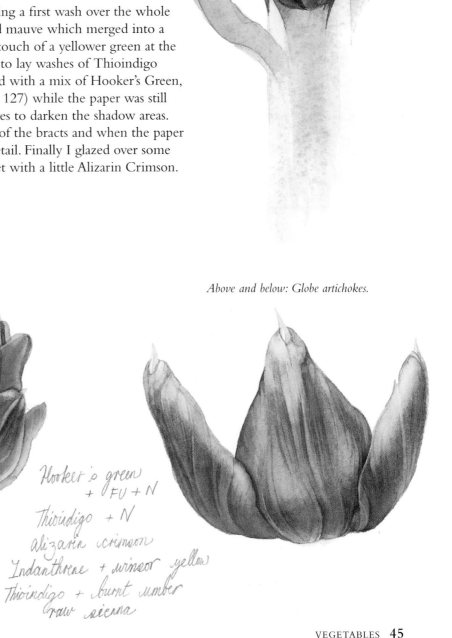

Above and below: Globe artichokes.

Hooker's green
 + FU + N
Thioindigo + N
alizarin crimson
Indanthrene + winsor yellow
Thioindigo + burnt umber
raw sienna

cerulean +
cad. lemon
+ FU

ONIONS

Although I didn't intend to include any onions in my final assignment, I wanted to paint one as an exercise in texture. Texture had been emphasized as an important aspect in the realistic portrayal of vegetables, and I thought it would be interesting to try to depict the papery fragility of the dry outer skins contrasting with the smooth sheen of the skin beneath. I built up the round form of the onions with layers of transparent washes applied wet-into-wet. When these were dry I started working up the texture using the dry-brush technique. Once I was satisfied with the detail I carefully glazed over with more transparent washes to liven up the colours.

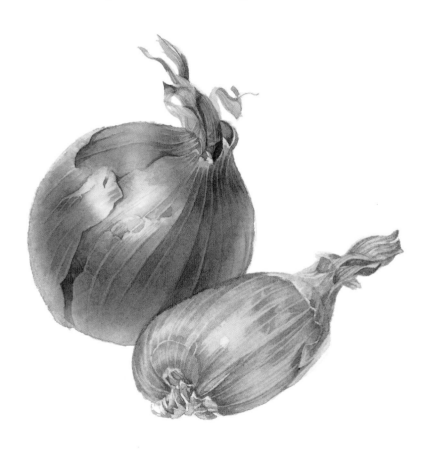

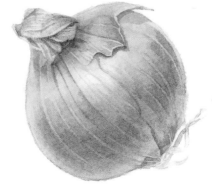

Right and above: Onions.

TURK'S CAP SQUASH

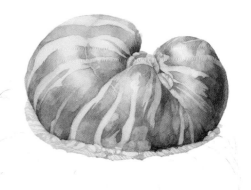

In the autumn, squashes, pumpkins and gourds start to appear in every shape and size. When I spotted a turk's cap squash at the market I couldn't resist its elegant stripes and lovely variations of brown splashed with green and orange.

I considered this as a possible subject for the finished assignment and after drawing a simple outline in pencil, I mixed Cadmium Lemon with a touch of Neutral (see page 127) and glazed it over the upper section of the squash, leaving the highlights untouched. When this had dried I mixed a wash of Burnt Umber and Permanent Mauve. I indicated the position of the stripes lightly in pencil and then painted them in using the darker mix and a smaller brush, being careful to leave not only the highlights, but the areas that would eventually become green or orange. When this was dry I began painting in the other colours, but found it difficult to control the washes and keep the variations of colour clean. Reluctantly, I decided to abandon this effort.

Another attempt at an ornamental squash was more successful. The pattern of spots and blotches on the 'turban' presented less variety and contrast of colour, and I could concentrate on showing the solidity and roundness of the form. I began with a wash of Sennelier Yellow Deep mixed with Raw Sienna. When this was dry, I began building up tone and detail with a mix of Scarlet Vermillion and Cadmium Yellow Pale.

burnt umber + perm. mauve

cad lemon + N + cad. red

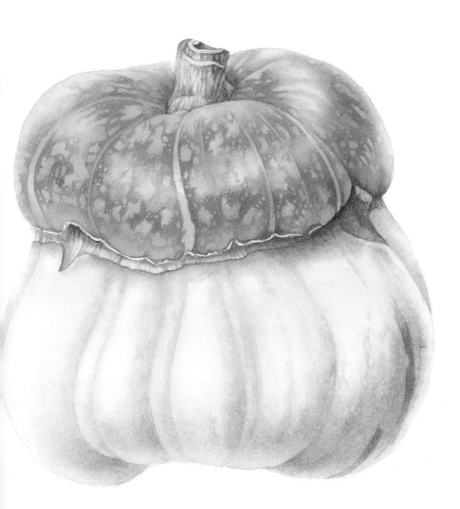

Left and above: Turk's cap squashes.

AUBERGINES

The moment was fast approaching when I would have to make a choice for the finished assignment. I liked the idea of a composition based on artichokes and aubergines. The highly polished surface of an aubergine would make an interesting contrast with the rougher artichokes, and there would be plenty of tonal variations from an almost black violet to mauve and subtle greens.

I began by drawing the longer, oblong aubergine shown here. After mixing three washes consisting of Winsor Violet with Payne's Grey, Purple Madder with Neutral (see page 127) and Winsor Violet with Neutral, I laid them in succession, wet-into-wet. I took care to leave a generous area of white paper for the highlight because I wanted as much tonal contrast as possible to show the glossiness of the surface.

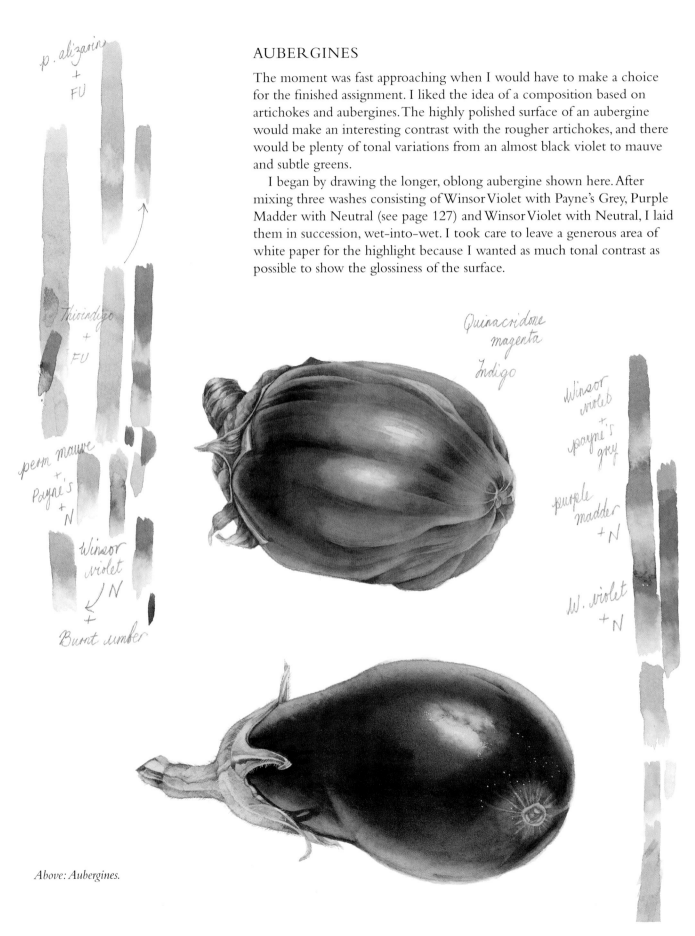

Above: Aubergines.

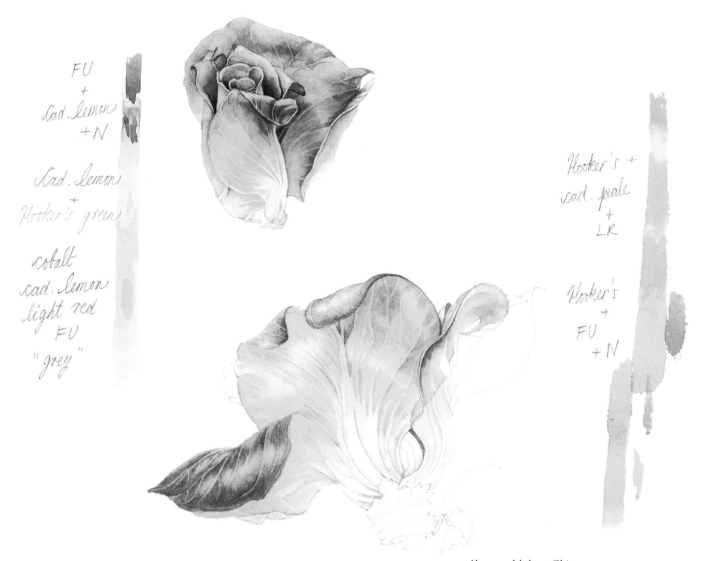

FU
+
Cad. lemon
+ N

Cad. lemon
+
Hooker's green

cobalt
cad. lemon
light red
FU
"grey"

Hooker's +
cad. pale
+
LR

Hooker's
+
FU
+ N

Above and below: Chicory.

THE ASSIGNMENT

Another trip to the market resulted in my bringing home a bag full of quite different vegetables. This time my attention had been caught by the narrow, snaking leaves of radicchio Tardivo, so called because it is traditionally produced later in the winter than the more common radicchio varieties, the result of a long, patient process of blanching and forcing. Not only do the leaves make a delicious pasta sauce cooked with cream and bacon, but the radicchio also proved rewarding to paint. I particularly liked the way the leaves entwined and curved in on themselves. The fleshier white part of the leaf showed hints of Permanent Magenta, whereas towards the tip a lemony green showed up well with the rich reds of the leaf edges.

After deciding that the radicchio could provide a strong focal point in the composition, I began hunting around for other vegetables that would provide contrasts of colour and shape. It seemed to me that a bunch of *grumoli*, a variety of chicory, with their tight little rosettes of vivid green leaves would make a good background to the radicchio. I also planned to add some radishes to balance the composition and liven up the colour scheme with their attractive red skins.

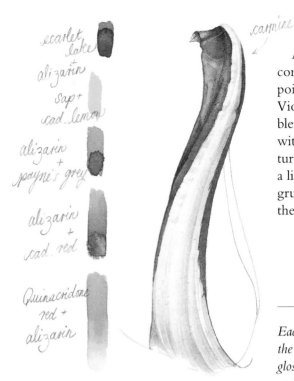

scarlet lake

alizarin

sap + cad. lemon

alizarin + payne's grey

alizarin + cad. red

Quinacridone red + alizarin

carmine

After making some rough pencil sketches to help me plan out the composition I began working on the two heads of radicchio. My starting point was the outer leaves, which I painted with a basic mix of Thioindigo Violet and Permanent Alizarin Crimson. Touches of Rose Madder were blended wet-into-wet along the edges, and the shadows were darkened with a mix of Purple Madder and Neutral (see page 127). Where the leaves turned away from the light and a cooler tint was needed, I glazed over with a light wash of Permanent Magenta. I particularly liked the crispness of the grumoli leaves, and the way the dark green gradually faded to yellow and then to white at the base.

TUTOR'S COMMENTS

Each of the preparatory items in the sketchbook is a gem, and I particularly liked the various purple tones and textures of the aubergines and artichokes, the former so glossy they looked polished.

Mary Ann must have been spoilt for choice when she selected items for her finished assignment. The unusual composition appealed to Billy Showell, who is no stranger to the creation of a contemporary layout that is eye-catching and moves botanical painting away from the formality of its traditional presentation. For this piece she awarded a very inspiring 96 per cent, which must have been a great boost to Mary Ann's confidence. She would now go from strength to strength.

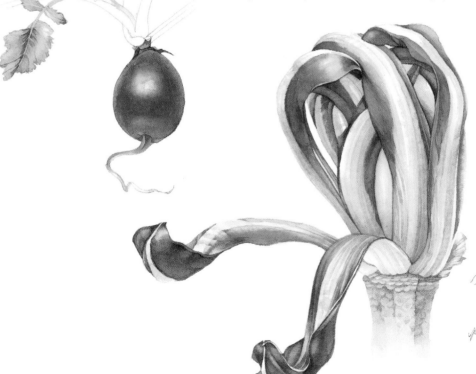

carmine

Thioindigo
perm. alizarin
rose madder
purple madder
+ N
cerulean + cad. lemon + N
Indigo
perm. magenta

Top and right: Radicchio. Above: radishes.
Opposite page: The final assignment: Radicchio, chicory and radishes.

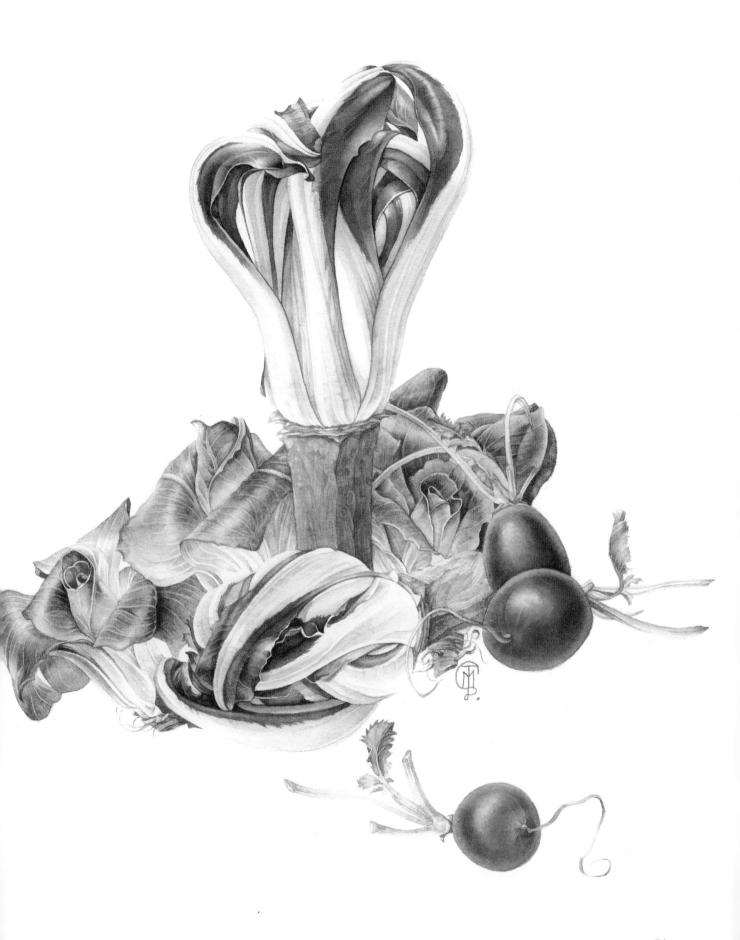

ASSIGNMENT 7
Botanical Illustration

Margaret Stevens: *This assignment calls for a classic botanical illustration, not a botanical painting. The former requires that all the relevant parts of the plant are portrayed, including style, ovary, calyx and root or bulb, each of which is an aid to identification by the taxonomist. Although accurate overall in its depiction of the subject, a botanical painting is a portrait, painted for pleasure rather than as an aid to scientific knowledge. In an illustration we look for total accuracy, from the number of stamens to the shape of the anthers or the difference in colour between new and old terrestrial roots on a phalaenopsis.*

Mary Ann Scott: Accuracy of size, form and colour would be fundamental to this assignment. I wanted to imagine that I was painting some new species and try to look at my subject through the eyes of a botanist, selecting and clarifying details which might contribute to the classification of the plant.

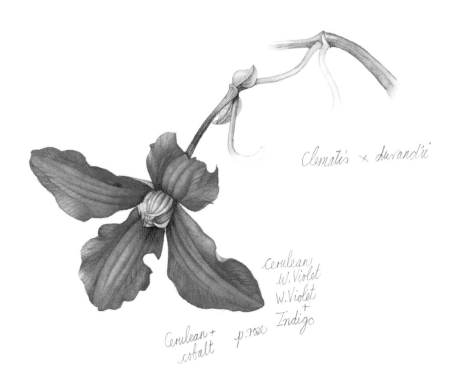

Above: Clematis x durandii. *Opposite page:* Helleborus orientalis.

LENTEN ROSE

In late winter the plum-coloured flowers of *Helleborus orientalis*, the Lenten rose, begin to unfurl. I was looking for a plant I could show in various stages of development, and a large clump growing in my garden provided me with both mature and juvenile leaves, a multitude of buds and open flowers and some seedheads that were beginning to develop.

I made some preparatory sketches to explore the structure of the flowers. Careful observation showed subtle variations of colour from a deep, muted violet to a mauve containing hints of pink or blue and an underlying pale acid green. The depth of colour depended on the maturity of the flower, the buds showing a more intense mauve.

My first wash on the flowers was a transparent mix of Alizarin Crimson and Permanent Mauve. When this had dried, I began painting the intricate pattern of veins, glazing each one while still wet with the brush dampened in clean water to soften the lines. I tried to keep the depiction of the veins to a minimum as I did not want the petals to look too busy. The shadows were built up with a mix of Purple Madder and Payne's Grey. When I was satisfied with the tonality of the petals, I started to add their speckled texture by dipping my brush in the mix of Purple Madder and Payne's Grey and fanning out the hairs on a piece of kitchen paper before dragging the brush gently over the petals. Finally, I mixed a watery wash of Cerulean and Cadmium Lemon with a touch of Neutral (see page 127) and glazed over the parts of the petal where the pale green appeared. When this was dry I emphasized some of the pinker areas of the petal with more Alizarin Crimson.

perm. mauve
+ N

p. mauve
+
p. alizarin

cerulean
+
cad. lemon
+ N

FU +
aureolin +
LR

purple
madder +
payne's
grey

FU
+
cad.
lemon
N+

Lemon
yellow
+
FU

lemon yellow
← perm. magenta
quinacridone magenta

p. mauve
+
p. alizarin
+ N

CAMELLIA JAPONICA 'HAGOROMO'

On my Saturday morning trip to the market I was stopped dead in my tracks by a colourful display of *Camellia japonica* among the fruit and vegetables. It was too hard to resist and my small garden subsequently began to fill up with pots of these spectacular plants. They are widely grown in this part of Northern Italy, and the villa gardens on the shores of Lago Maggiore are famous for their displays of camellias. Many beautiful and well-known varieties were developed in this area in the 19th century.

I am particularly fond of the shell-pink flowers of *Camellia japonica* 'Hagoromo' and this was my first choice of subject. The cup-shaped flowers looked easier than the more double varieties and I began working on some preparatory sketches. The difficulty lay in trying to capture the delicate pink colour of the petals, which at times seemed to suggest underlying hints of yellow and in other places seemed almost white. I tried an underlying wash of Naples Yellow followed by a basic mix of Permanent Rose and Cadmium Yellow Pale with additional touches of Permanent Rose and Lemon Yellow. My choice of shadow colours, Mid Grey and Permanent Rose, and Ultramarine Violet didn't satisfy me either. I was finding it difficult to build up enough tone to give shape and depth without spoiling the velvet softness of the flower.

FU + Cad. lemon + N

Camellia japonica 'Hagoromo'

naples yellow
perm rose + cad. pale
mid + perm. rose
+ ultramarine
violet

FU +
cad. pale + cad. red
cerulean + cad. lemon

Above: Camellia japonica *'Hagoromo'*

CAMELLIA JAPONICA 'BONOMIANA'

The elaborate *Camellia* 'Black Lace' was fun to paint, but after spending an entire morning on the drawing I felt it would be an over-ambitious choice for the final assignment.

The large, elegant flower of *C. japonica* 'Bonomiana' looked less challenging and had the additional attraction of pure white petals streaked with crimson. My exploratory painting in the sketchbook showed me that this would be a fine choice for the assignment. I particularly liked the glossy dark-green leaves, which contrasted beautifully with the pink and white flowers.

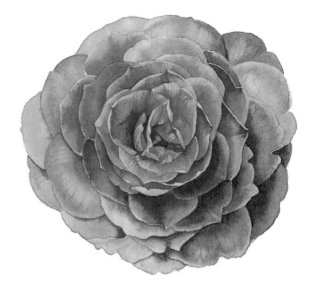

Camellia 'Black Lace'

Above: Camellia 'Black Lace'.
Left and below: Camellia 'Bonomiana'.

perm. rose
+
cad. pale
'mid' + perm. rose
naples yellow
———
alizarin – quinacridone
red
alizarin + perm. rose

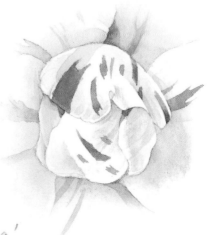

Camelia japonica 'Bonomiana'

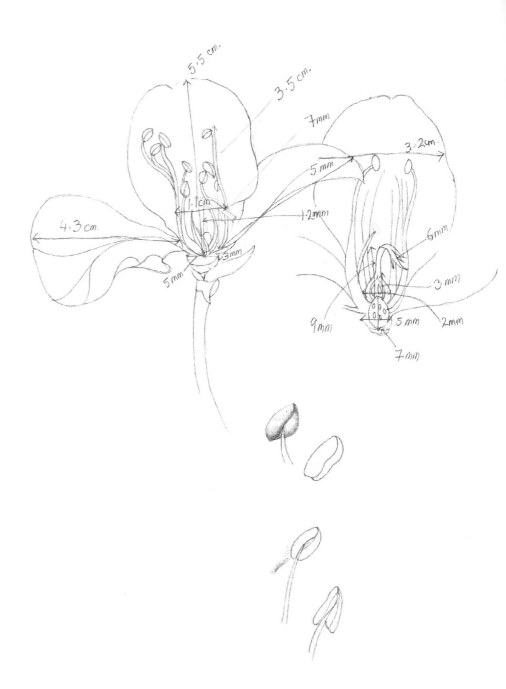

DISSECTION

I was happy with my preparatory studies and began planning the composition. However, before starting on the painting I wanted to try out some dissections. My potted specimen of *Camellia japonica* 'Bonomiana' had few open blooms, so I decided to practise on a flower of *C. japonica* 'Hagoromo' instead. To keep the flower as fresh as possible I placed it on cotton wool in a saucer filled with water, and set about removing the parts gradually to take the measurements I needed before it wilted completely. Arming myself with tweezers, scissors and scalpel, I began removing petals and part of the stamens and made an initial sketch. I took the necessary measurements and then proceeded to remove more petals and make another rough sketch. Finally, I used my scalpel to bisect the ovary and reveal the ovules. These sketches and measurements could then be used to reconstruct a more precise finished painting of the dissected flower.

Above: Preparatory sketch of flower dissection.
Opposite page: Preparatory sketches: stamens and petals.

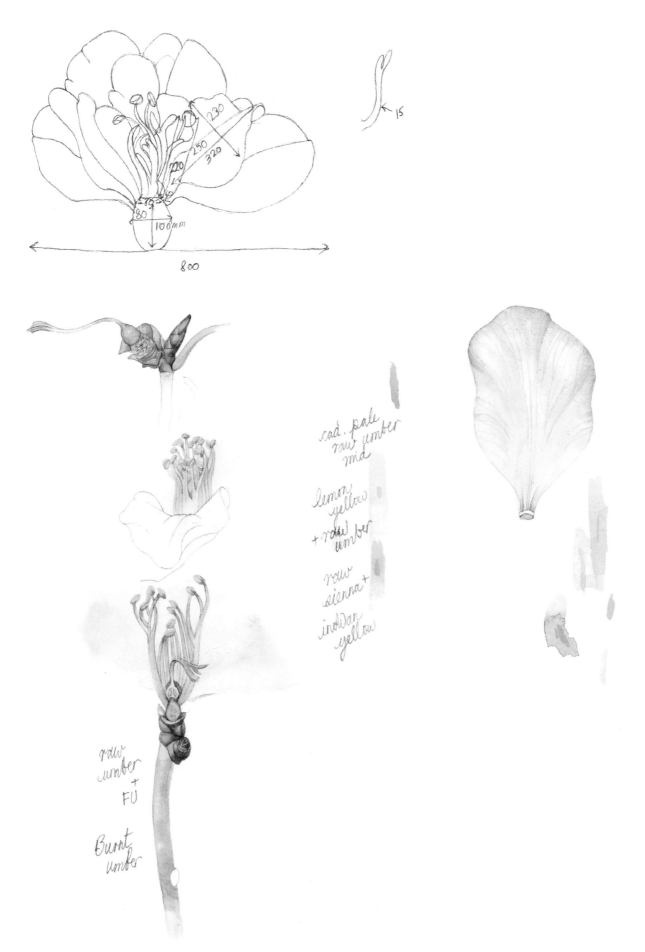

230

250

320

220

80

100mm

800

15

cad. pale
raw umber
mid

lemon
yellow
+ raw
umber

raw
sienna +
indian
yellow

raw
umber
+
FU

Burnt
umber

THE ASSIGNMENT

I wanted the composition to show as many different aspects of the plant as possible, even if this entailed sacrificing some aesthetic considerations. I was doubtful about the short stem holding the central bloom. It looked too stiff, but it was typical of this camellia so I decided to leave it as it was.

The open bloom could be treated as a white flower, with the streaks of crimson added when the basic structure of petals and stamens was completed. I used a mix of Alizarin and Quinacridone Red where the streaks seemed more pronounced, and a mix of Alizarin Crimson and Permanent Rose where I wanted to give a softer, faded impression. I discovered that I could use the streaks to help give shape and depth to the petals.

Having completed the central flower, I turned my attention to the leaves, which were painted using a basic mix of French Ultramarine and Cadmium Lemon to which I added a little Neutral (see page 127). The duller undersides of the leaves were painted with the same mix with added Raw Umber. I wanted to show the difference between the older stems, which were greyer and more textured, and the redder, smoother stems of the previous year's growth. In the upper right of the page I added a curved stem carrying a heavy weight of three fat buds showing different stages of development.

TUTOR'S COMMENTS

Camellia japonica 'Bonomiana' is a joy to paint. The splashes of red help to give form to the complex mass of petals, which is a great help to the artist exploring their structure. The buds shown at the top right of the composition introduce a fresh lime green, which seems to illuminate that corner and contrasts nicely with the dark green leaves.

The composition works well and by touching the central flower with a leaf from the upper stem Mary Ann has held it together and prevented the top bloom from floating in space. This very beautiful painting with well-placed dissections deserved the mark it was given of 135 out of 150.

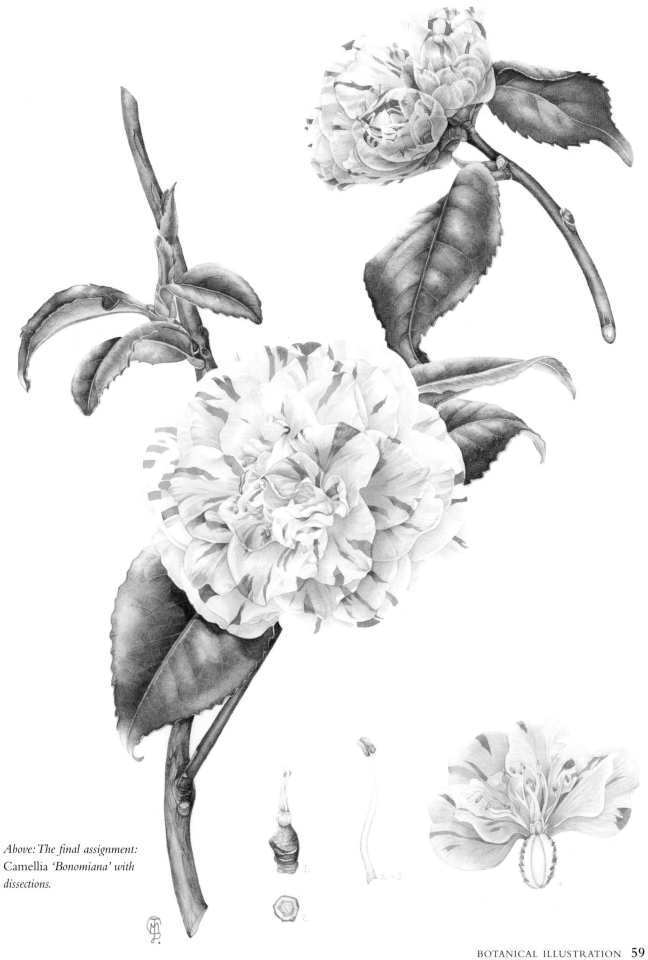

Above: The final assignment:
Camellia *'Bonomiana'* with
dissections.

ASSIGNMENT 8

Working in the Field

Margaret Stevens: *For this assignment, the students must work outside. We ask them to choose a site, study the flora over time and record it in their sketchbooks. Eventually we want to see one or two complete pages of worked-up studies from these notes and observations. This is the closest our students will come to sharing the experiences of artists such as John Sibley and Jacques le Moyne de Morgues who accompanied expeditions in the past – though, working closer to home, the students will not encounter the life-threatening hazards these men faced.*

Mary Ann Scott: This assignment seemed rather alarming. The moment had come when I would have to abandon the comfort of my work-place and brave the elements, yet I also felt a tingle of excitement – surely this was what being a botanical illustrator was all about.

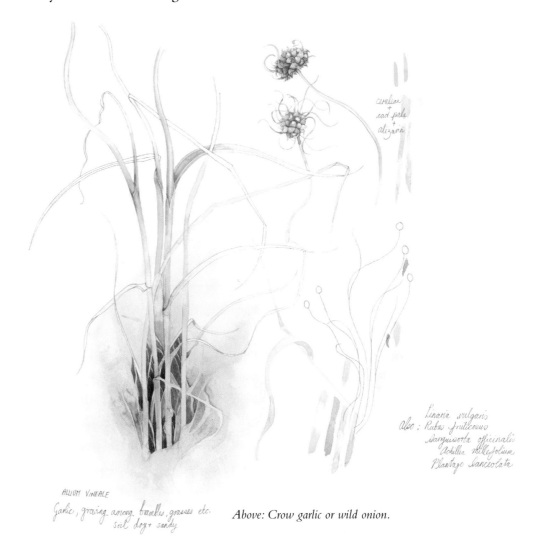

Above: Crow garlic or wild onion.

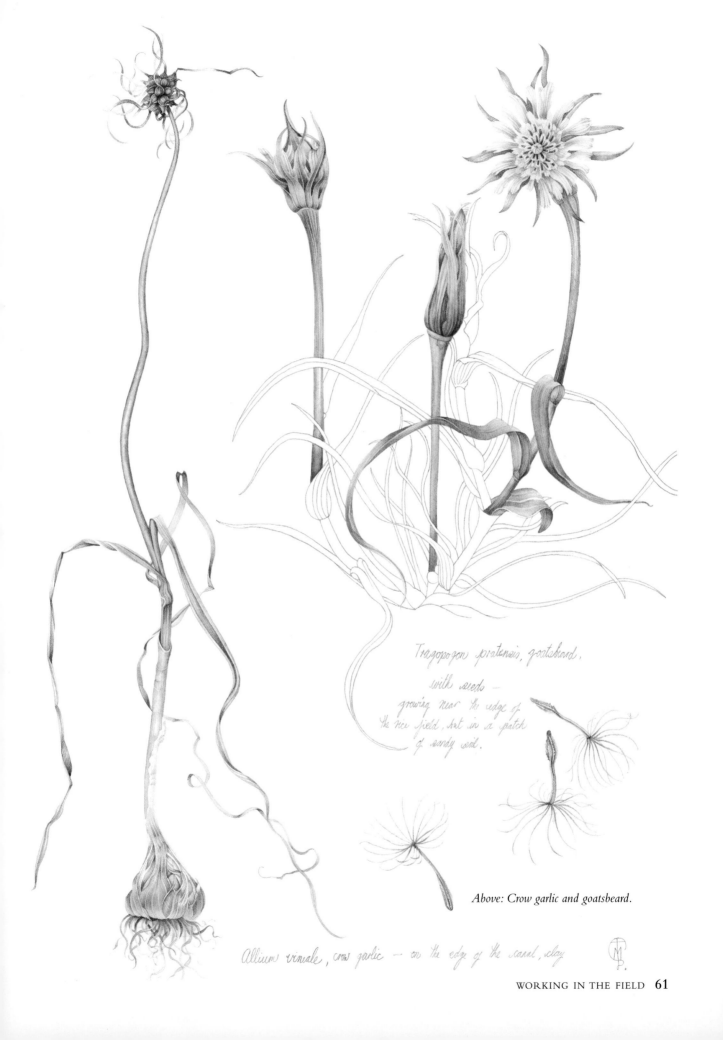

Tragopogon pratensis, goatsbeard.

*with seeds —
growing near the edge of
the rice field, but in a patch
of sandy soil.*

Above: Crow garlic and goatsbeard.

Allium vineale, crow garlic — on the edge of the canal, clay

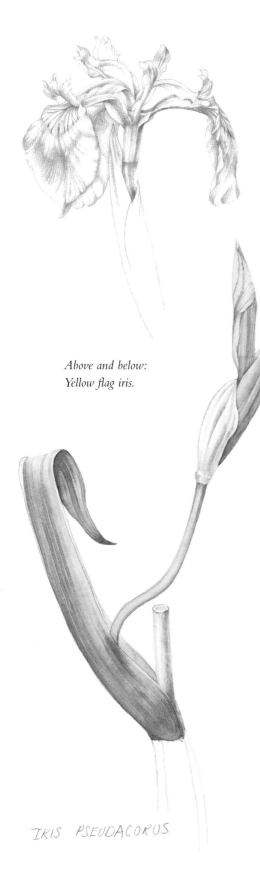

Above and below:
Yellow flag iris.

IRIS PSEUDACORUS

THE HABITAT

The first step was to select a habitat that was easily accessible to me. I decided that the rice fields near my house would be an obvious choice as I had walked my dog there every morning for years and was familiar with this environment.

It is a curious landscape, apparently flat and featureless. Large, square fields are broken up by a network of small irrigation ditches that dry out during the winter but are filled by water from the larger canals in early spring. When the rice is planted the fields are flooded, and for a brief period the scenery is transformed; water is everywhere, gurgling along the ditches or lying in vast mirrors, reflecting the sky and the distant alps.

I decided to concentrate on the plants growing on the banks of the small irrigation ditches. Unfortunately, the farmers regularly spray with herbicides as well as frequently cutting back new growth along the ditches to keep them clear. Despite this, I found a surprising variety of wild flowers growing in the predominantly clay soil.

YELLOW FLAG

I carefully closed my box of watercolours with a strong elastic band and put it into a small backpack together with pencils, brushes, a jar of water, paper towels, mosquito repellent and my pocket guide to wild flowers. My dog looked at me expectantly, sensing adventure. I grabbed my bicycle and off we went for a morning in the fields.

I knew where I was heading. I had already spotted a large clump of *Iris pseudacorus* (yellow flag) growing in the mud at the water's edge. Settling down on the grassy bank, I began sketching the open flowers, trying to put in as much detail as possible with a view to the finished painting. Once I had made several line drawings and a more carefully constructed tonal study, I started working in colour, concentrating on aspects that might be useful later. I tried to catch the subtle variations of yellow I could see on the petals and the silky texture of the tightly furled buds. I was also interested in the semi-transparent, parchment-like texture of the leaves where the flower stems appeared. All these small details would be important when the time came to reconstruct the whole stem with the buds and flowers.

GOATSBEARD

This was a challenge! Goatsbeard, according to Geoffrey Grigson in his fascinating book *The Englishman's Flora*, is a 'clock plant', closing at midday. One of its folk names is 'Jack-go-to-bed-at-noon', but clearly its Anglo-Saxon relatives were a livelier set than my plant – it drew the curtains promptly at 10 o'clock each morning, which meant I had to work really fast to try to record all the details of the flower. I did not want to give up, though, as I loved the grassy, glaucous leaves and the puffball seedheads.

My chosen specimen was thriving in a patch of sandy soil further up the bank from the yellow flag. I arrived early and began a pencil study of the open flower. When I had recorded the detail I needed for the final painting I made a rough watercolour sketch with ample colour notes. The next step

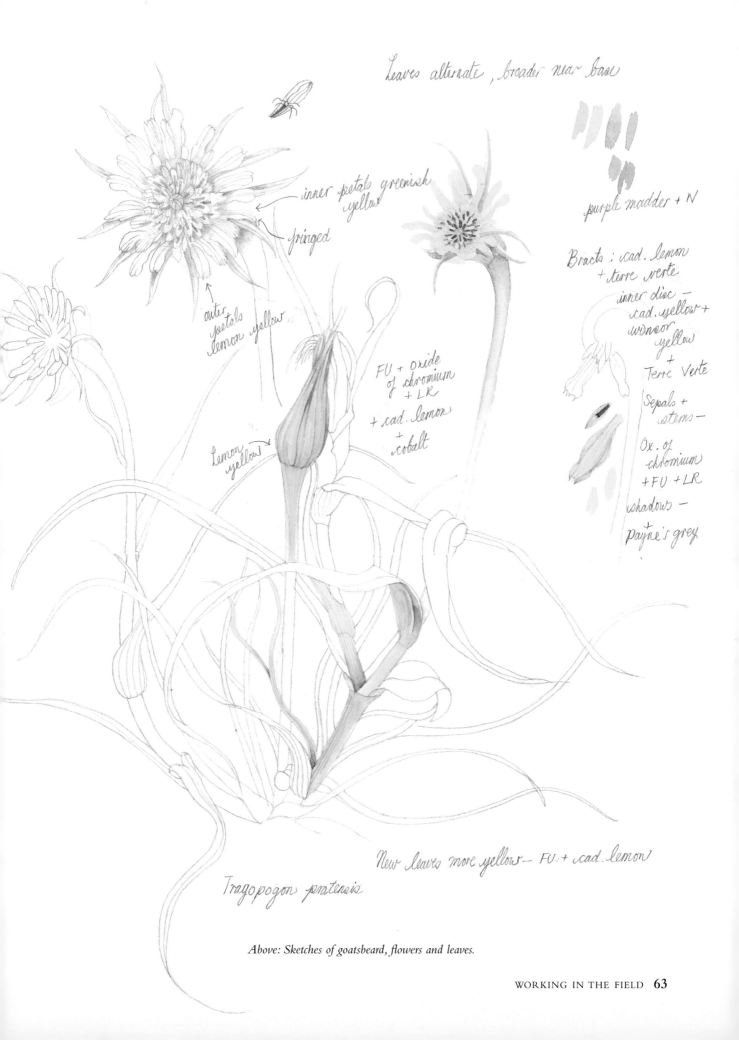

Leaves alternate, broader near base

inner petals greenish yellow

fringed

outer petals lemon yellow

purple madder + N

Bracts : cad. lemon + terre verte
inner disc — cad. yellow + windsor yellow + Terre Verte

Sepals + stems —

Ox. of chromium + FU + LR

shadows —

Payne's grey

Lemon yellow

FU + oxide of chromium + LR + cad. lemon + cobalt

New leaves more yellow— FU + cad. lemon

Tragopogon pratensis

Above: Sketches of goatsbeard, flowers and leaves.

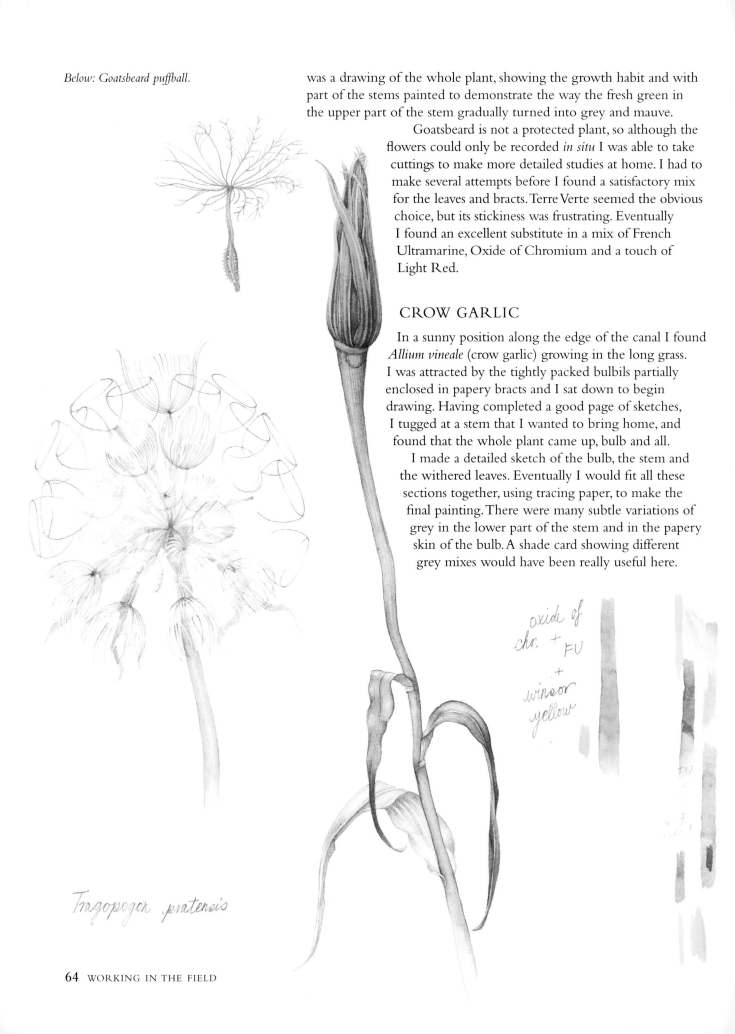

Below: Goatsbeard puffball.

was a drawing of the whole plant, showing the growth habit and with part of the stems painted to demonstrate the way the fresh green in the upper part of the stem gradually turned into grey and mauve.

Goatsbeard is not a protected plant, so although the flowers could only be recorded *in situ* I was able to take cuttings to make more detailed studies at home. I had to make several attempts before I found a satisfactory mix for the leaves and bracts. Terre Verte seemed the obvious choice, but its stickiness was frustrating. Eventually I found an excellent substitute in a mix of French Ultramarine, Oxide of Chromium and a touch of Light Red.

CROW GARLIC

In a sunny position along the edge of the canal I found *Allium vineale* (crow garlic) growing in the long grass. I was attracted by the tightly packed bulbils partially enclosed in papery bracts and I sat down to begin drawing. Having completed a good page of sketches, I tugged at a stem that I wanted to bring home, and found that the whole plant came up, bulb and all.

I made a detailed sketch of the bulb, the stem and the withered leaves. Eventually I would fit all these sections together, using tracing paper, to make the final painting. There were many subtle variations of grey in the lower part of the stem and in the papery skin of the bulb. A shade card showing different grey mixes would have been really useful here.

oxide of chr. + FU + winsor yellow

Tragopogon pratensis

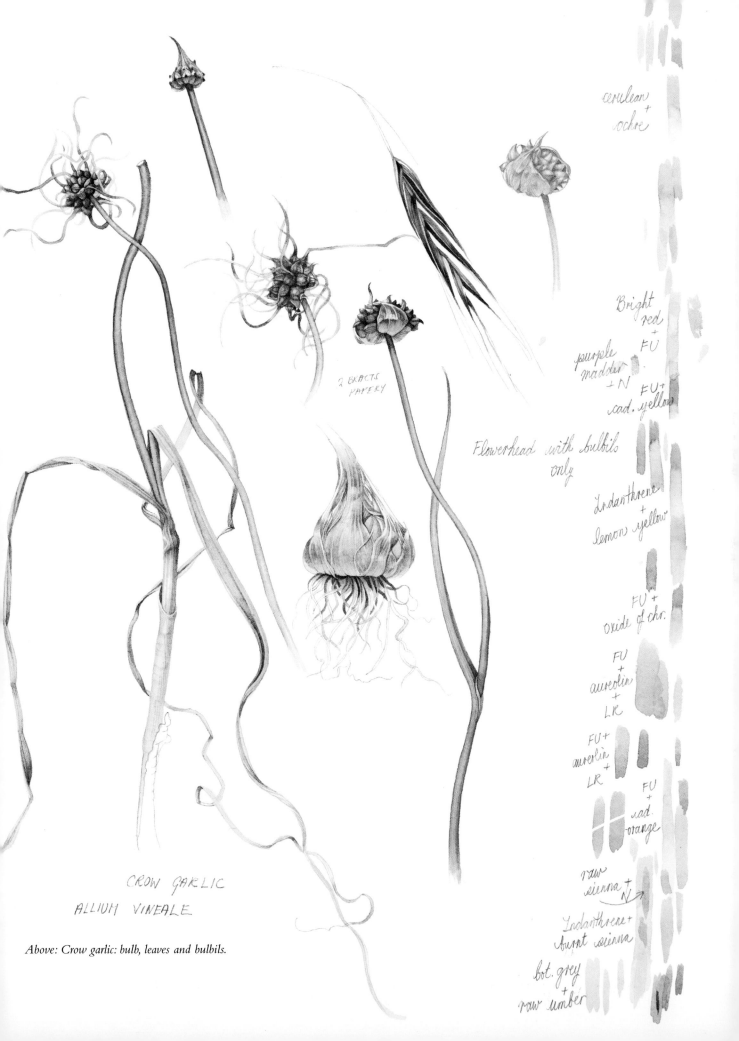

cerulean
+
ochre

Bright
red
+
FU
purple
madden
+ N
FU +
cad. yellow

Flowerhead with bulbils
only

Indanthrene
+
lemon yellow

FU +
oxide of chr.

FU
+
aureolin
+
LR

FU +
aureolin
+
LR
FU
+
cad.
orange

raw
sienna +
N

Indanthrene +
burnt sienna

bot. grey
+
raw umber

2 BRACTS
PAPERY

CROW GARLIC
ALLIUM VINEALE

Above: Crow garlic: bulb, leaves and bulbils.

THE ASSIGNMENT

I had been going out into the fields regularly for weeks, drawing and painting a variety of flowers that seemed to appear and disappear almost from day to day as the season moved towards midsummer. I had accumulated a thick wad of sketches, including studies of a clump of grass with *Leucanthemum vulgare* (ox-eye daisy), *Equisetum arvense* (horsetail fern) and *Vicia cracca* (tufted vetch), which I was planning to work up into my habitat painting. Now I had to select the plants I would use for the finished assignment. Using my sketches, I made detailed tracings of the chosen subjects and used them to plan out the composition.

All my earlier apprehension had vanished. Looking back, I think I enjoyed this assignment more than any other. It was not just that I had had to try different working methods which had proven both instructive and rewarding, but perhaps more that I had the pleasure of sitting on a grassy bank, feeling the sun on my back and discovering how much beauty and variety could grow out of one tiny patch of earth.

IRIS PSEUDACORUS

FU +
cad. lemon
+ LR
+ N

cobalt

FU +
cad.
lemon +
LR +
sap +
gamboge

mid
+
cad lemon

raw umber
cobalt

more grey
+
transparent
(Davy's grey?)

TUTOR'S COMMENTS

Working in the Field is often one of the more challenging assignments but here Mary Ann really excelled herself. Two sheets of exquisitely drawn wild flowers painted with delicacy and care raised her work to an even higher level. Her tutor, Reinhild Raistrick, herself familiar with working on overseas locations, was bowled over by it and awarded 98 per cent. The composition is faultless as the eye is led from one subject to the next and every pencilled line has purpose.

Above: Yellow flag iris.
Opposite page: The final assignment: yellow flag iris with seedhead and dissection, water figwort, ox-eye daisy with grasses, vetch and horsetail ferns.

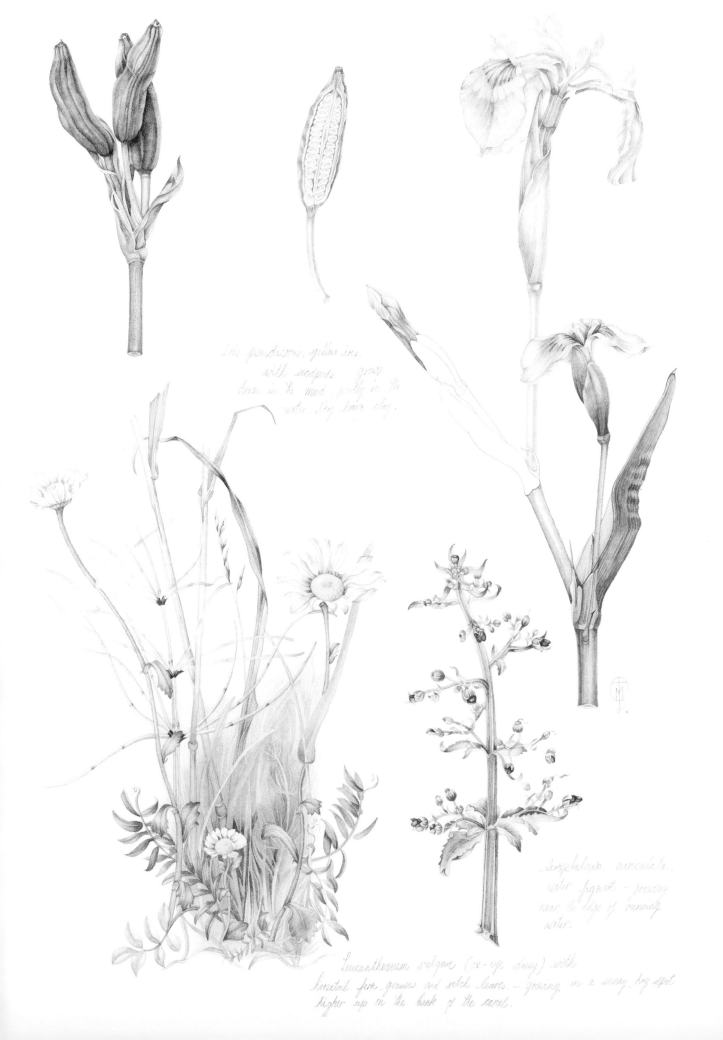

Iris pseudacorus, yellow iris
with seedpods - grows
down in the mud, partly in the
water. They have clay.

Scrophularia auriculata,
water figwort - growing
near the edge of running
water.

Leucanthemum vulgare (ox-eye daisy) with
horsetail fern, grasses and vetch leaves - growing in a sunny, dry spot
higher up on the bank of the canal.

ASSIGNMENT 9

Working from Photographs

Margaret Stevens: *A botanical artist who hopes to work commercially has to accept that the ability to paint from photographs is a necessity. If one is fortunate enough to find a publisher who requires original art rather than photographs, deadlines mean that it is not possible to wait around for the true flowering season. Serious commercial artists build up an extensive reference library of their own photographs – no right-minded artist will use other people's and risk infringement of copyright.*

Using photographic reference in this way is not an easy option – skill is required to ensure correct perspective and consistent lighting in multiple photographs.

Mary Ann Scott: I was looking forward to embarking on this assignment. I imagined a relaxing two months seated at my desk sheltered from the August heatwave, painting flowers that would never wilt or begin to perform gymnastics as the light changed. It was a pleasant dream. In reality the assignment was much more complicated and demanding than I had envisaged.

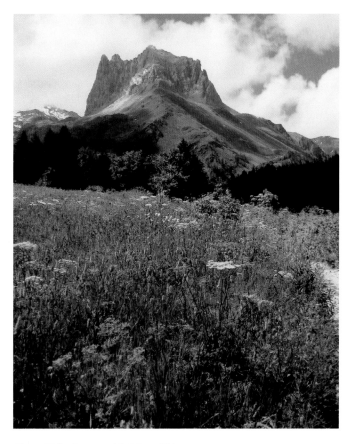

Above: Valle Stretta with Monte Tabor.

VALLE STRETTA

When the summer holidays arrive the population of Italy is neatly divided between those who go *al mare* (to the seaside) and those who prefer *la montagna* (the mountains). Belonging to the latter, I had spent two weeks with my family near Bardonecchia in the Val di Susa. One of our favourite walks took us along a path which climbed through alpine meadows and cool pine woods to a small lake. To anyone with even the smallest botanical interest this walk along the Valle Stretta is a stroll through paradise, such is the richness and variety of the flora.

The assignment was based on the idea of a greetings card design, and flowers in their natural habitat was one of the possible subjects. A couple of afternoons spent exploring the meadows with my camera provided me with a wealth of photographs from which to paint.

Below: Valle Stretta painting.

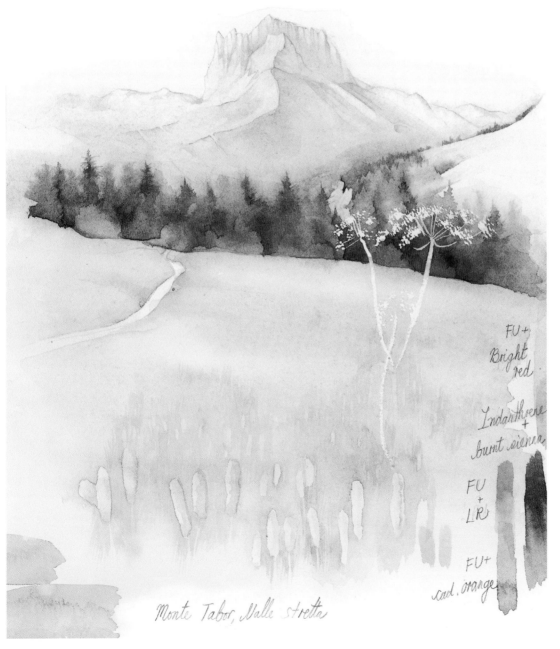

FU+
Bright
red.

Indanthrene
+
burnt sienna.

FU
+
LR

FU+
cad. orange.

Monte Tabor, Valle stretta

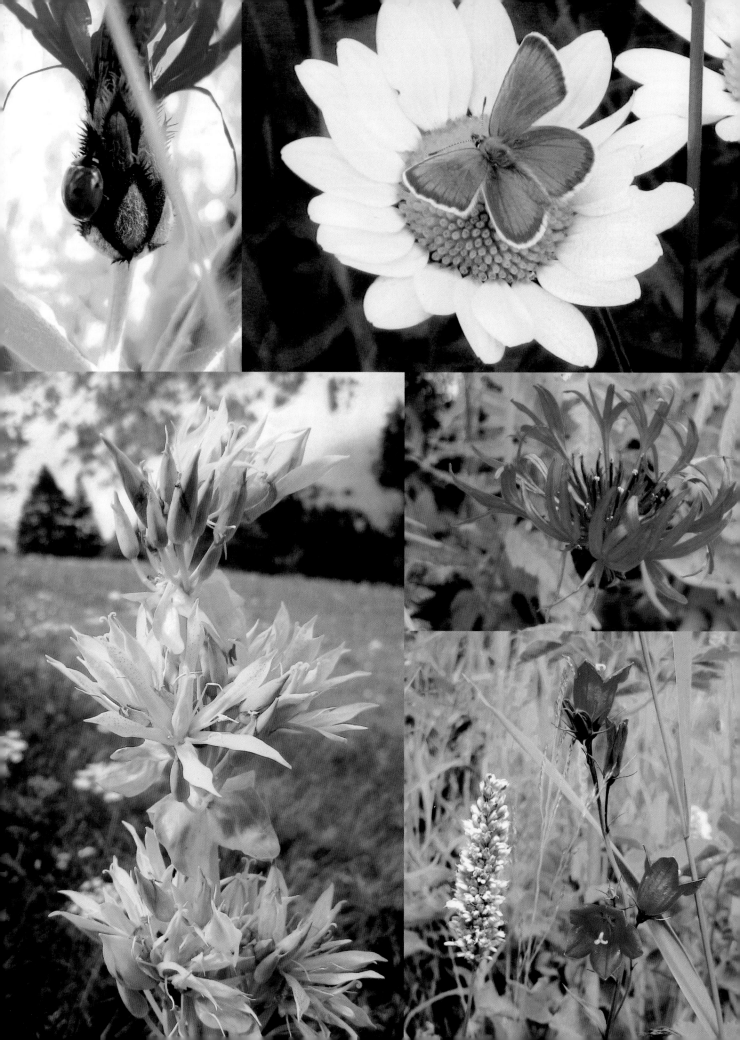

COLOUR STUDIES

As I took my photographs I was forming ideas for a composition and considering which flowers to focus on. The meadow was dotted with the statuesque spires of *Gentiana lutea* (great yellow gentian) and these would surely add drama. I noted other plants such as *Centaurea montana* (perennial cornflower) and *Leucanthemum vulgare* (ox-eye daisy) that I might place in the foreground and photographed them in detail, recording images of foliage and stems as well as the flowers.

At this early stage it was important to make colour notes, bearing in mind that the colours reproduced in the photographs would probably be inaccurate. The experience of working in the field for the previous assignment came in useful here and I also made some quick sketches, recording colours and details that might easily be overlooked with only the photograph as reference.

Below: Colour notes: scabious, bistort and gentian.

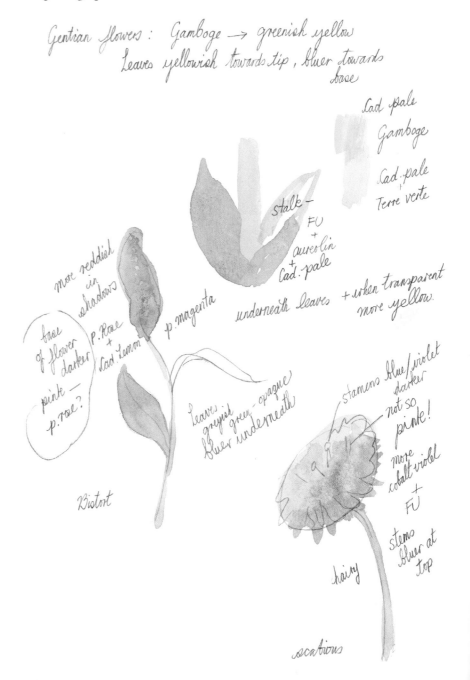

Gentian flowers: Gamboge → greenish yellow
Leaves yellowish towards tip, bluer towards base

Cad. pale
Gamboge
Cad. pale
Terre verte

stalk —
FU
+
aureolin
+
Cad. pale

underneath leaves + when transparent more yellow.

more reddish in shadows

base of flower darker

P. Rose + Cad. Lemon

p. magenta

pink — p. rose?

Leaves greyish green-opaque bluer underneath

Bistort

stamens blue/violet darker
not so pink!
more cobalt violet + FU
stems bluer at top

hairy

scabious

GENTIAN AND OX-EYE DAISY

Back at home, it was time to begin making individual sketches of the main actors in my composition. I started on details of the great yellow gentian, which I was going to assemble using a photograph of the whole plant. The difficulty here was to maintain the correct proportions between the separate parts, and I made several pencil sketches with this in mind. Using my colour notes for reference, I painted details of the clusters of buds and open flowers, trying different mixes to catch the subtle nuances of greens and yellows. The broad, strongly ribbed leaves were lovely to paint. Their large, simple shapes would be important in the composition, contrasting well with the busier areas of grass and smaller flowers.

Below: Great yellow gentian.

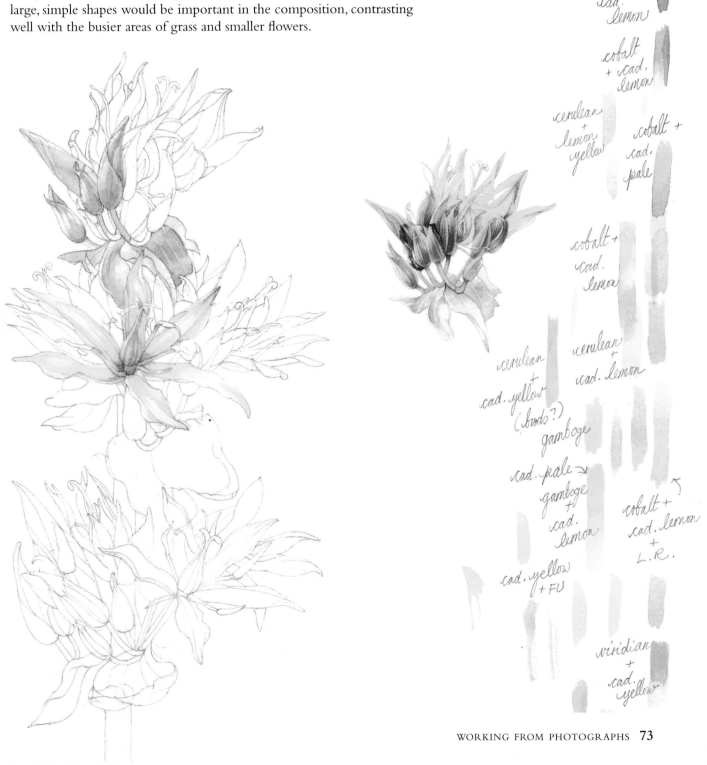

FU + cad. lemon

cobalt + cad. lemon

cerulean + lemon yellow

cobalt + cad. pale

cobalt + cad. lemon

cerulean + cad. yellow (buds?)

cerulean + cad. lemon

gamboge

cad. pale → gamboge + cad. lemon

cobalt + cad. lemon + L.R.

cad. yellow + FU

viridian + cad. yellow

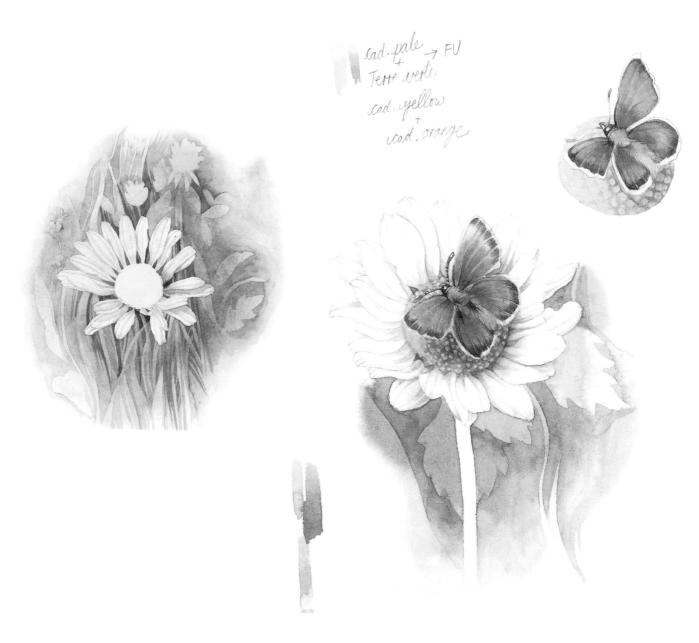

Above: Ox-eye daisy.

I had painted ox-eye daisies in my last assignment, and I liked the way the petals could be picked out and their whiteness emphasized by a background of greens and browns. Now I had to decide how much detail to paint into the disc florets – I wanted to show the spiral arrangement but without overpainting and muddying the fresh yellow. I had managed to photograph a butterfly resting briefly on a daisy flower, and this piece of luck offered an additional way of solving the problem of the florets.

VIOLA, CORNFLOWER AND HAREBELL

Some of the flowers were to be painted in detail, appearing more in focus, and others such as the clovers, perennial cornflower *(Centaurea montana)* and speedwell *(Veronica alpina)* would be painted in a looser way, blending into the grasses. The dainty mountain pansy *(Viola lutea)* proved quite difficult, as I wanted to make a precise painting but without giving the impression that it was floating in space. While laying the background washes I had to be careful not to build up hard, rim-like edges.

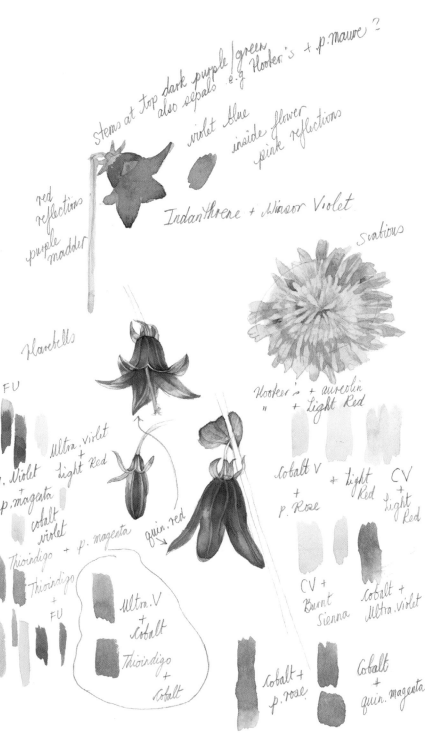

The handwritten notes accompanying the studies read:

stems at top dark purple / green
also sepals e.g Hooker's + p.mauve?

violet blue

inside flower
pink reflections

red reflections
purple madder

Indanthrene + Winsor Violet

Scabious

Harebells

FU

W. Violet

Ultra. Violet
+
light Red

p. magenta

cobalt
violet

Thioindigo + p. magenta

quin. red

Thioindigo
+
FU

Ultra. V
+
Cobalt

Thioindigo
+
Cobalt

Hooker's + aureolin
" + Light Red

cobalt V
+
P. Rose

+ light
Red

CV
+
Light
Red

CV +
Burnt
Sienna

cobalt +
ultra.violet

cobalt+
p. rose.

Cobalt
+
quin. magenta

Left: Scabious and harebell.

When I began making studies of the perennial cornflower (*Centaurea montana*) I was pleased to have the photographs to help me describe the complex structure of inner and outer florets. However, I was beginning to discover that the luxury of having the photograph in front of me and not having to worry about the flower wilting also tended to encourage fiddling. Self-control was required in order to avoid overpainting and spoiling the freshness of these mountain flowers. The harebells (*Campanula rotundifolia*) were particularly delicate. I painted them using watery washes of Cobalt Blue mixed with Ultramarine Violet, picking out the pinker reflections with a mix of Cobalt Blue and Permanent Rose, while the deeper shadow areas were darkened with a mix of Cobalt Violet and French Ultramarine.

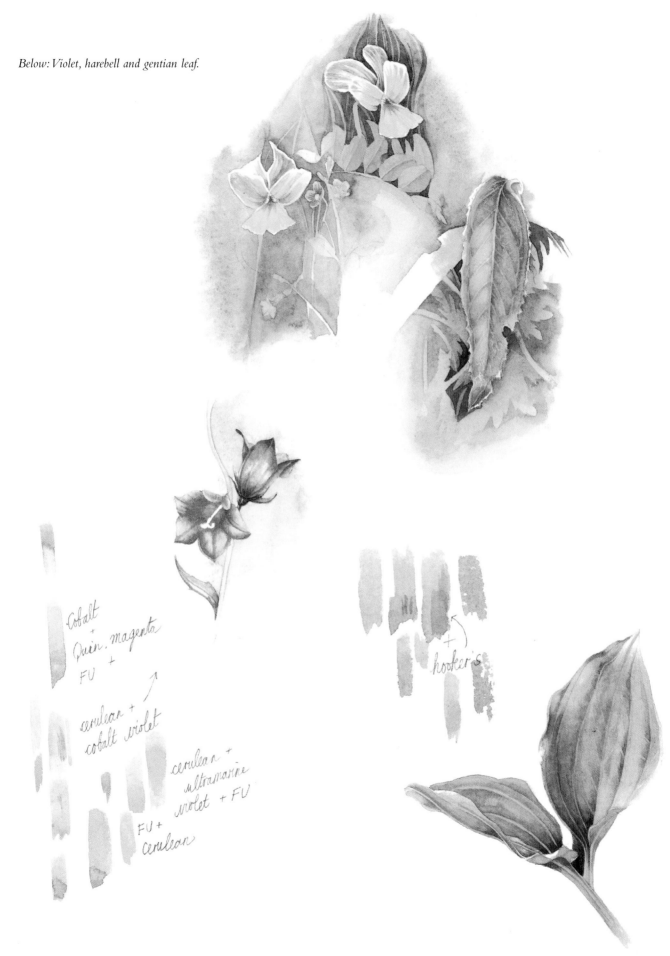

Below: Violet, harebell and gentian leaf.

Cobalt
+
Quin. magenta
FU +

cerulean +
cobalt violet

cerulean +
ultramarine
violet + FU

FU +
cerulean

+
hooker's

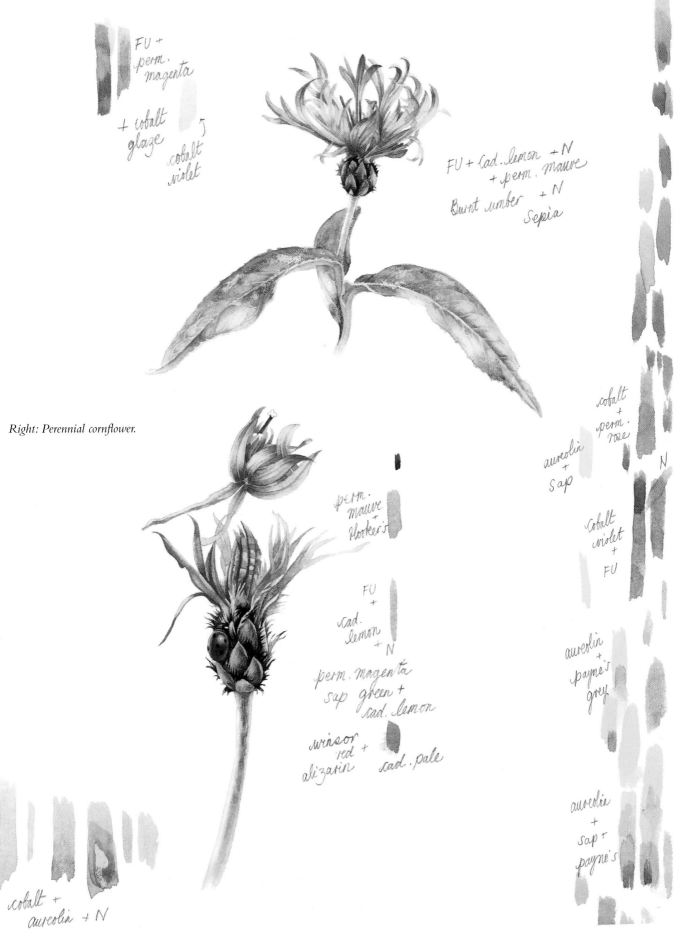

FU +
perm.
magenta

+ cobalt
glaze

cobalt
violet

FU + cad. lemon + N
+ perm. mauve
Burnt umber + N
Sepia

Right: Perennial cornflower.

cobalt
+
perm.
rose

aureolin
+
Sap

Cobalt
violet
+
FU

perm.
mauve
+
Hooker's

FU
+
cad.
lemon
+ N

aureolin
+
payne's
grey

perm. magenta
sap green +
cad. lemon

winsor
red +
alizarin cad. pale

aureolin
+
sap +
payne's

cobalt +
aureolin + N

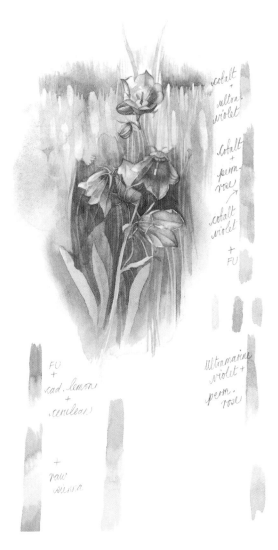

COMPOSITION

When I had gathered enough material to begin planning the composition in detail, I began making tracings of the more important elements that would form the basic structure. I had prepared a rough pencil sketch on a piece of A3 paper to give me an idea of the relative proportions. Now I could move my separate tracings around to see where each plant would best fit.

To create depth I planned to focus on the larger, detailed flowers in the foreground, which would gradually become softer as the eye was gently led up towards Monte Tabor and the distant mountain ranges. I used different tactics to reinforce this impression, such as the path winding up to the treeline and the cool, soft colour in the distance, becoming more vivid in the foreground where the ladybird would provide a splash of warm red to enliven the dominant blues and greens. The fence post was put in to give solidity and structure to a composition that would otherwise consist almost entirely of a sea of waving grasses and flowers.

THE ASSIGNMENT

Once I had assembled the main elements of the composition in a satisfactory way I fixed them to the paper and began tracing over the whole picture. I then transferred this tracing to the piece of A3 watercolour paper onto which I would paint the finished work. When I had completed the pencil drawing, I carefully cleaned off all extraneous traces of pencil and began to lay the first watery washes.

I started working around the painting, building up the different areas as appropriate. I began with the gentian, which I thought was the most difficult plant to paint, and then moved on to complete the mountains in the background. Gradually I worked in the foreground details and the misty central area. Eventually, with a sigh of relief, I found myself painting the last wispy grasses, and it dawned on me that I had finished this very demanding assignment.

Above and below: Harebell.
Opposite page: The finished assignment.

TUTOR'S COMMENTS

From the rice fields of northern Italy to the Alps for this tricky assignment which involved working from photographs. I have some idea of the amount of effort required to succeed with this particular type of painting. There are those who scoff at the idea of using photographic reference, but in order to work commercially it is imperative. At the most elementary level some people simply copy photographs, but here great care was needed to build up the painting, making sure the perspective and proportions were correct. The scarlet ladybird is the work of a true artist – one brilliant spot of colour to excite the eye and draw the viewer into the painting.

I marked this myself and felt happy all day as a result, giving it 96 per cent. I only complained about the poor butterfly, whose wings are definitely wonky!

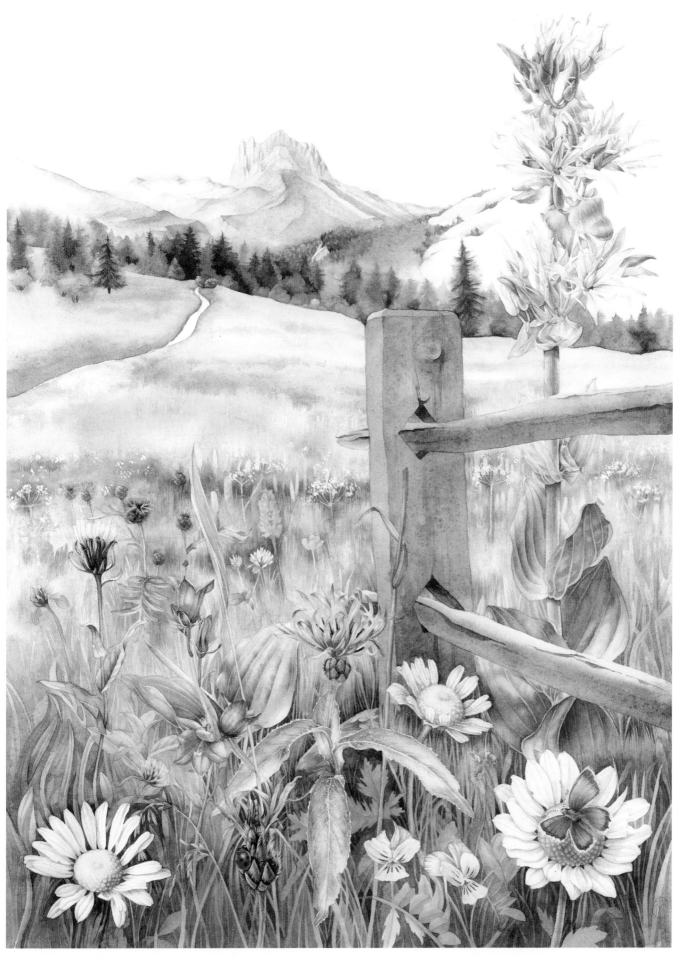

ASSIGNMENT 10
Mixed Flowers

Margaret Stevens: *Tackling a painting of mixed flowers is the most challenging task in the course so far, requiring compositional acumen and an eye for flower arranging, albeit on paper instead of in a vase. Badly done, all the flowers will typically face the front and the composition will look flat. With care the arrangement can appear to be three-dimensional and the painting will have depth, making the viewer feel that there is a 'back' to the image.*

Mary Ann Scott: This mixed flower assignment was more complex than anything I had yet undertaken, and I would have to plan carefully if I wanted to achieve a harmonious composition. I imagined that the process would be rather like walking through the garden, a bunch of flowers in one hand and secateurs in the other, adding a bloom from time to time, a flower arrangement in progress.

perm. alizarin ↗

viridian +
lemon
yellow
+
LR ↗

perm.
alizarin
+
N
perm. alizarin

Viridian
+
cad.
lemon
+
FU

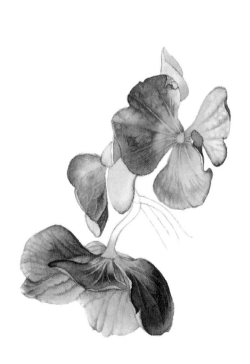

Above: Hydrangea.

cobalt +
cad. lemon

cad. orange
bright red
alizarin

crataegus ?

Winsor
violet
+
payne's
grey.

Indanthrene
blue +
perm.
mauve

BERRIES

I wanted my composition to have an autumnal feel with bright hips or
berries and the warm colours of turning leaves. I was attracted by the
faded corymbs of a hydrangea, which had lost its vivid pink colour and
was mellowing into shades of muted crimson and lime green.

Before beginning on the berries and rose hips, I thought I should
practise the wet-into-wet techniques I had used for painting vegetables in
the sixth assignment. I had to make several attempts before I was satisfied.
There was very little space to control the washes and I needed to simplify
the process to achieve smooth tonal transitions, using finer brushes and
keeping the washes relatively dry.

*Above: Rosehips, firethorn berries,
hawthorn berries and wild vine berries.*

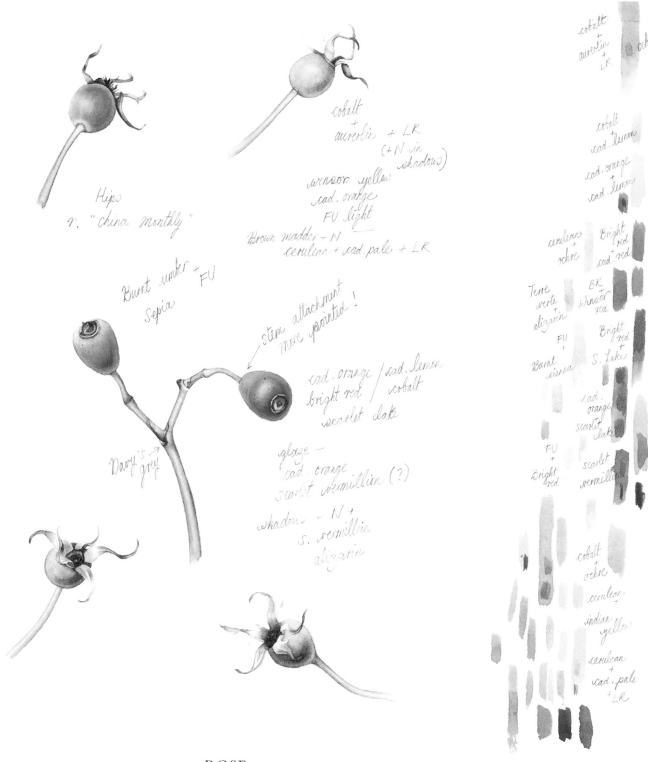

Hips
r. "china monthly"

Burnt umber + FU
Sepia

Davy's grey

stem attachment
more pointed!

cobalt
+
aureolin + LR
(+ N in shadows)
winsor yellow
cad. orange
FU light
Brown madder + N
cerulean + cad. pale + LR

cad. orange / cad. lemon
bright red / cobalt
scarlet lake

glaze -
cad. orange
scarlet vermillion (?)

shadow - N +
S. vermillion
alizarin

cobalt
+
aureolin
+
LR

oh

cobalt
cad. lemon

cad. orange
+
cad. lemon

cerulean
+
ochre

Bright
red
cad. red

Terre
verte
+
alizarin

BK
+
winsor
red

FU

Bright
red
+
S. Lake

Burnt
sienna

cad.
orange
scarlet
lake

FU
+
Bright
red

scarlet
vermillion

cobalt
+
ochre

cerulean
+
indian
yellow

cerulean
+
cad. pale
+ LR

Above: Rosehips.

ROSE

I planned to construct the painting around two entwined stems of *Rosa chinensis* 'Old Blush', also called the China monthly rose because of its long flowering season. A garish shade of pink during the hot summer months, the flowers soften to a more delicate shade as the weather cools in autumn. Apart from its ability to provide a constant supply of blooms, buds and hips, this generous rose is also endowed with long, graceful stems which would aid the composition.

A painting of an open flower in my sketchbook came out well and encouraged me to begin work on the assignment piece. After making

a light pencil drawing of the rose, I began painting each petal separately, using a watery mix of Permanent Rose with a touch of Cadmium Yellow Pale. I noticed that my subject had an unfortunate tendency to move and, feeling slightly panicky, I tried to work as quickly as possible. I built up the shapes of the petals with additions of the basic Permanent Rose mix and then deepened the shadows with Ultramarine Violet. Finally, I added tints of Viridian and Lemon Yellow where appropriate.

With the flower completed, I began work on the top section of the stem, leaves and buds. I left the lower section lightly drawn in pencil in case

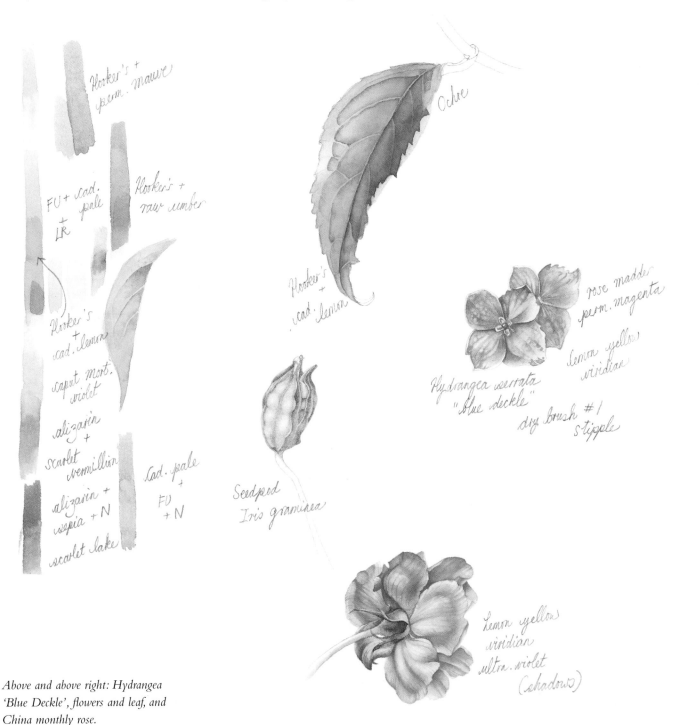

Above and above right: Hydrangea 'Blue Deckle', flowers and leaf, and China monthly rose.

I had to overlap stems or leaves at a later stage. I wanted to show another open bloom, facing away, and an opening bud. At this stage I decided to follow the working method that I had learned in Assignment 8, making detailed paintings in my sketchbook and using tracings to help place them in the composition. By working in this way, I hoped to be able to plan the details of the composition more easily as the painting progressed.

Below: Tickseed (coreopsis), *Rose de Recht and China monthly rose.*

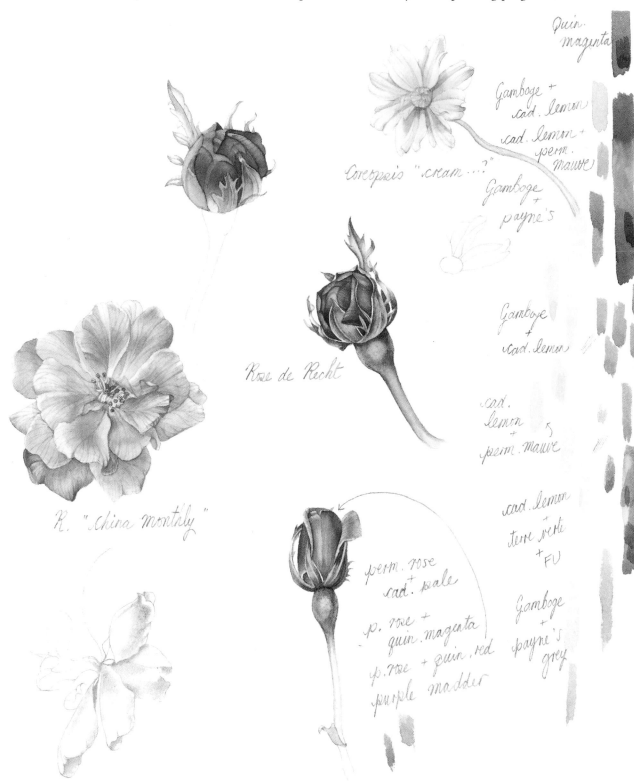

Quin. magenta

Gamboge + cad. lemon

cad. lemon + perm. mauve

Coreopsis "cream....?"

Gamboge + payne's

Gamboge + cad. lemon

Rose de Recht

cad. lemon + perm. mauve

R. "china monthly"

cad. lemon terre verte + FU

perm. rose + cad. scale

p. rose + quin. magenta

p. rose + quin. red

purple madder

Gamboge + payne's grey

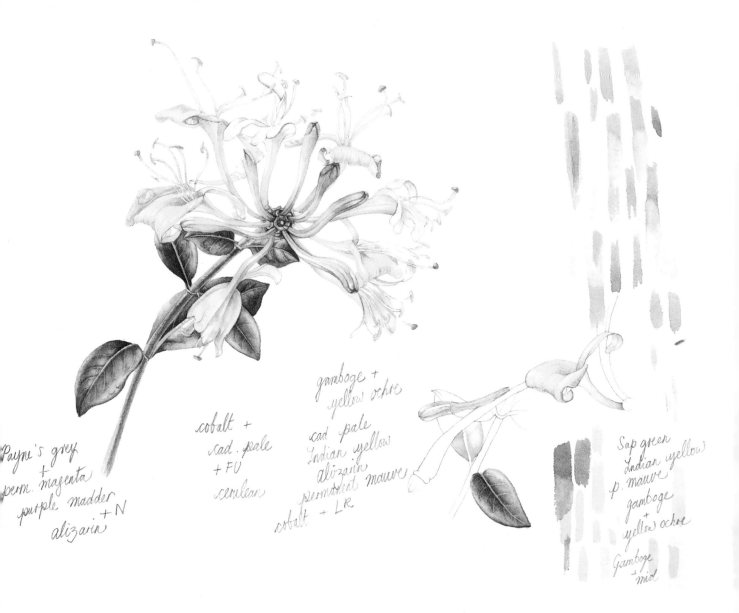

Handwritten colour notes:

Payne's grey
+
perm. magenta
+
purple madder
+N
alizarin

cobalt +
cad. pale
+FU
cerulean

gamboge +
yellow ochre
cad pale
Indian yellow
alizarin
permanent mauve
cobalt + LR

Sap green
Indian yellow
p. mauve
gamboge
+
yellow ochre

Gamboge
+ mid

HONEYSUCKLE

Next I started preparing sketches of a honeysuckle, *Lonicera periclymenum*
'Graham Thomas', which I feared was fast reaching the end of its flowering
season. I made several detailed sketches showing the flowers from different
angles which I could insert later, if needed. I was particularly keen to
capture the delicate shades of green along the peduncles. I found that a
fresh green mix of Cerulean, Cadmium Yellow Pale and French
Ultramarine worked well, glazed over with a little Winsor Lemon and
some touches of Quinacridone Red where the bud became pinker.

The flowers, pearly white as they opened, became yellower with age.
I painted the white parts with a 'botanical grey' mix of Cobalt Blue and
Light Red. The pink edge was added by first dampening the petal with
clean water and then painting the line with Alizarin Crimson, using a fine
brush, and letting the paint bleed a little into the petal. For the yellow
petals I used a mix of Gamboge Genuine and Yellow Ochre. Where the
curves of the petals required a more intense yellow I painted in Cadmium
Yellow Pale and Indian Yellow, and for the darker shadow areas I mixed a
little Permanent Mauve into the Gamboge mix.

Above: Honeysuckle 'Graham Thomas'.

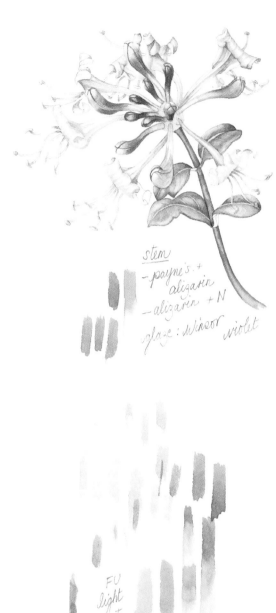

HYDRANGEA

I wanted to introduce some autumn colour and I thought that the brilliant leaves of *Hydrangea serrata* 'Blue Deckle' would fit in well. I began experimenting with different mixes, blending them through a spectrum of brown, scarlet, orange, yellow and green. I found that painting in all the details of veins and blemishes while keeping the colours alive and glowing was a lengthy undertaking, and I decided to paint only two of the larger leaves, which would form a background for the pale flowers of the honeysuckle in a large size; the others would be more modest in scale.

STEMS

I had been building up the painting gradually, positioning details as it took shape to keep the composition balanced. I had now reached the stage where I could start adding the hips and the honeysuckle berries, providing touches of brighter colour. I painted three rosehips, echoing the triangle formed by the two open flowers and the bud. Then I turned my attention to the stems, which I had left to last, lightly sketched in pencil, so that I would be able to make them weave in and out of the leaves and flowers and finally bring the painting together.

There was plenty of variety of colour and texture here. I particularly liked the violet hues in the honeysuckle stems, which gradually became greyer and woodier as they matured. I found that a mix of Payne's Grey and Permanent Magenta worked well, combined with a Purple Madder and Neutral mix (see page 127) where a deeper tone was required. At times the stems showed suggestions of red or green and I glazed over a little Alizarin Crimson or Viridian.

TUTOR'S COMMENTS

The mixed study is a delightful medley of summer flowers with a hint of autumn in the hips and turning leaves. Once again the tutor was Brigitte E. M. Daniel, who praised the drawing, colour, composition and technique. She rightly pointed out the white space to the left of the hydrangea leaf which draws the eye and Mary Ann could still add something there to improve this – but not a butterfly!

I have rarely known Brigitte so enthusiastic and the mark was an astonishing 142 out of 150.

Above: Honeysuckle.
Opposite page: The final assignment: China monthly rose, honeysuckle 'Graham Thomas' and hydrangea 'Blue Deckle'.

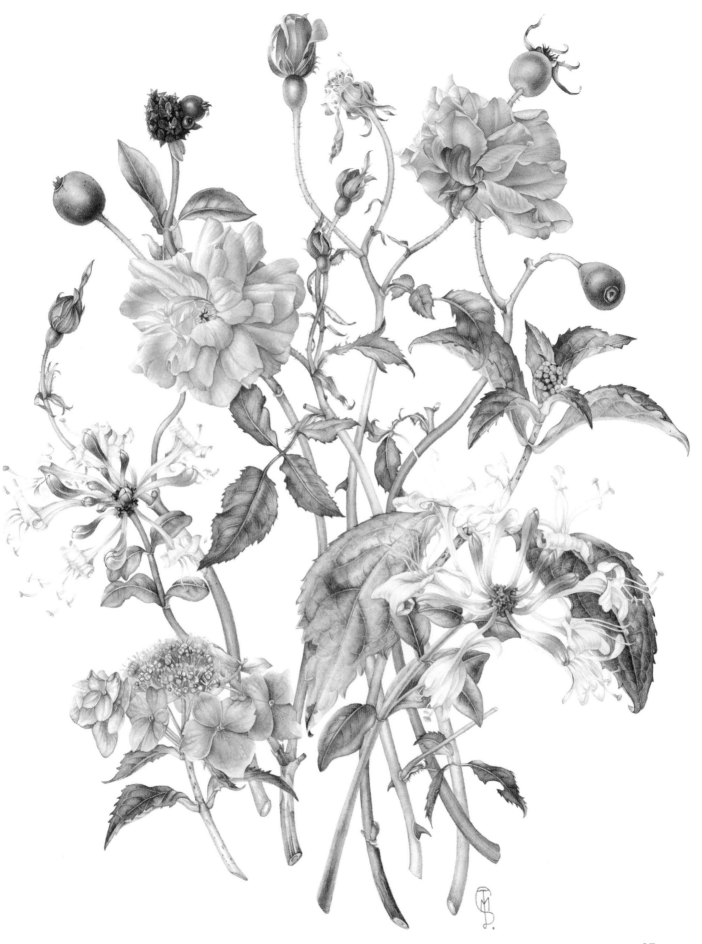

ASSIGNMENT 11

Diploma Portfolio

Margaret Stevens: *The three sections required for this final task bring together all the elements covered throughout the course. The examiners look for evidence of this and expect a more complex painting than any of those submitted for the previous assignments.*

Part 1 Fruit, Vegetables or Fungi
This gives the students a very wide choice and enables them to choose from a range that has probably given them one of their higher marks for the coursework.

Part 2 Botanical Illustration
Feedback on the earlier assignment should enable this to be tackled with more confidence, as any mistakes will have been pointed out and at least eight months will have passed in which to practise and improve any weak areas.

Part 3 Mixed Composition
The earlier assignment will have been painted in late summer or autumn. Now there is the opportunity to use early spring flowers, not just bulbs but wonderful shrubs such as camellias and mahonias.

Those of us who assess this work will have had several taxing days which also offer a great deal of pleasure – never more so than when, very occasionally, we come across something outstanding which lifts our spirits and makes all the hard work worthwhile.

Mary Ann Scott: As the earlier fruit and vegetable assignments had been enjoyable and had given me confidence, I thought I would begin with part 1 to give me a positive start, which would help to speed my progress through these challenging assignments.

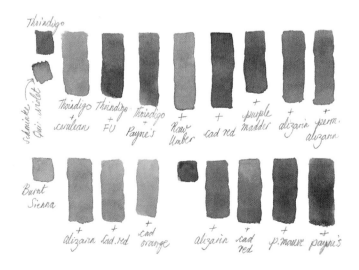

RED ONIONS

Turning the pages of my sketchbook in search of ideas, my glance fell on the three onions I had painted previously for Assignment 6 (see p. 46). I liked the glossy skins and glowing colour, and with ideas beginning to take shape I set off for the market. There were many strings of onions on display, but they were tied together too neatly. Eventually I found a string of Tropea onions that would be just right. They were loosely bound in a way that showed the interesting patterns of the entwined stalks.

In my first sketches I was principally concerned with rendering the different textures of the skins and I needed to see how much detail I could work in without the painting becoming too fussy. I could see so many variations of violet, pink and copper brown I decided to help myself by making a shade card of Thioindigo Violet, Burnt Sienna and Brown Madder mixes. For once, there was no real need to plan the composition. I fixed up my string of onions in front of me and got to work. I started by taking careful measurements with a ruler to help establish their position on the paper.

I began on the first onion by laying a wash of Thioindigo Violet mixed with Alizarin Crimson,

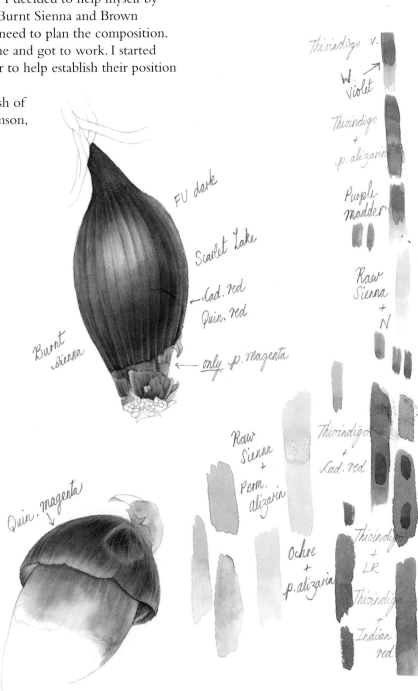

Opposite page: Shade card for red onions.
Above and right: Red onions.

wet-into-wet. When this was dry I painted the lines of the veins, dampening the paper on one side to allow the colour to spread. Now I began building up the tone with more glazes of the basic mix. When this seemed right I started adding textural details such as the tiny wrinkles and the splits in the skin, which I had not put in earlier as I had found it difficult to keep the washes uniform with so many different areas to deal with. The colours looked rather bland at this stage, so I began to glaze over with Scarlet Lake, Quinacridone Red or Cadmium Red. Where I needed more coppery reflections I used a wash of Burnt Sienna, for example; where I wanted the violet to glow around a highlight, Carmine worked well. Finally, I deepened shadowed areas using Caput Mortuum Violet over the warmer browns and pinks and Quinacridone Magenta mixed with Neutral (see page 127) over areas of violet.

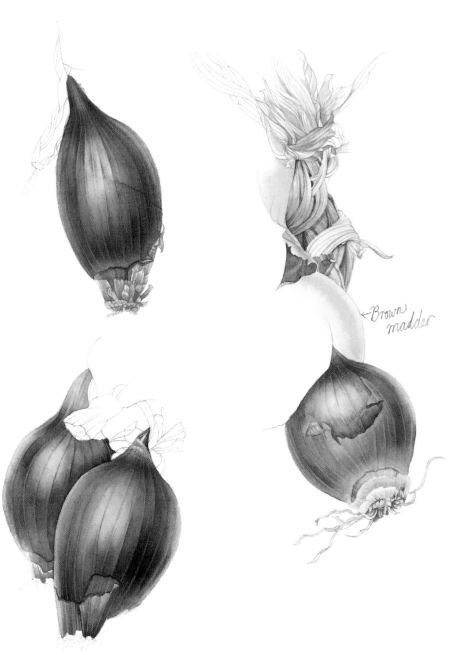

Above and right: Red onions.

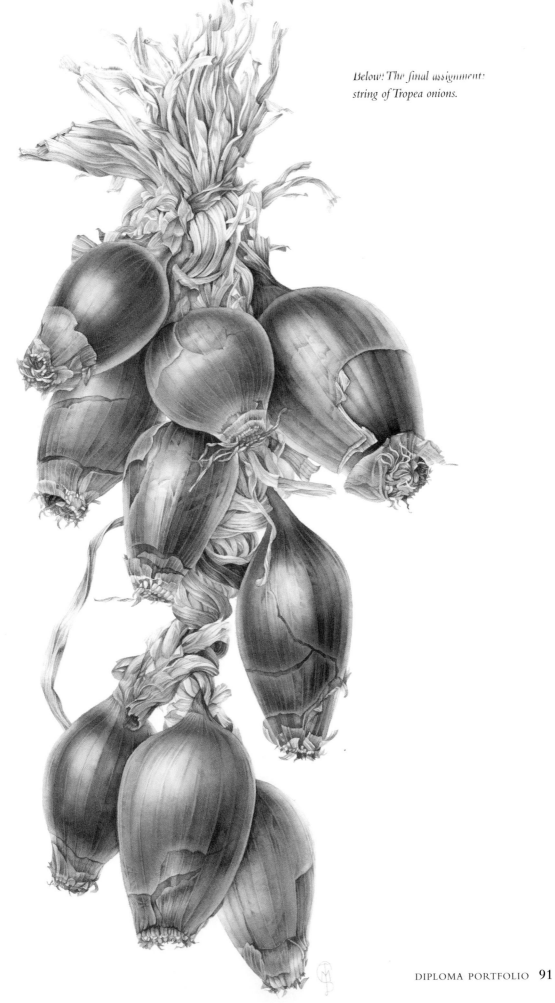

Below: The final assignment: string of Tropea onions.

CHRISTMAS ROSE

When I am hunting for ideas I sometimes look through my books on botanical painting and now, turning the pages of Shirley Sherwood's *A New Flowering*, my attention was caught by an illustration of *Helleborus officinalis* by Ferdinand Bauer (1760–1826) showing a dark tangle of roots behind the pale flowers. Christmas had passed but there were plenty of specimens of the Christmas Rose, *Helleborus niger*, coming into flower and I thought this might be a fine subject for Botanical Illustration, Part 2 of my portfolio.

I began sketching the open flowers, concentrating on showing the simple shapes of the petals without overdoing the grey tones. I made several sketches of buds which might be useful later if I needed to fill a space, and which would give me an opportunity to explore details of the bracts and fleshy stems.

Right: Christmas rose.

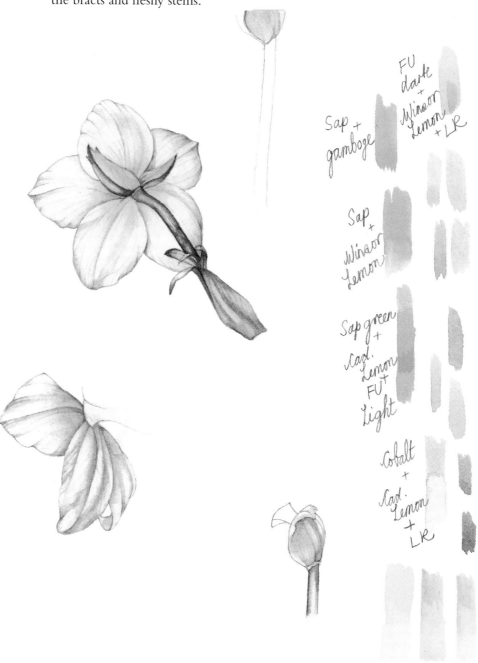

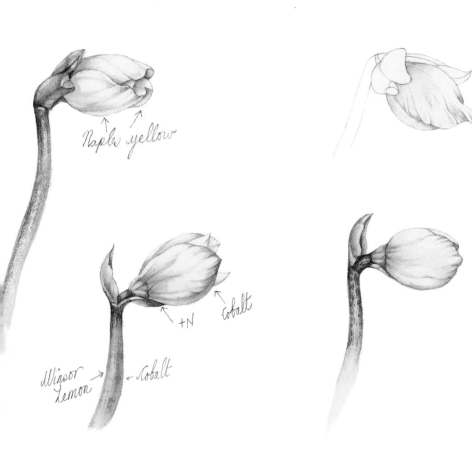

Hooker's green + cad. lemon

Brown madder + Purple madder + N

FU + W. Violet + Cad. Lemon

FU + aureolin + LR

olive green + cad lemon + FU light

Naple yellow

+N

cobalt

Winsor Lemon → *← cobalt*

Before beginning work on the finished painting I planned to make a precise study of the root system with comprehensive colour notes. I would then be able to use a tracing to place this in my composition. The first step was to measure the approximate length and width of the mass, and then I began drawing the more prominent roots before filling in details of those behind.

I wanted to show the roundness of the roots so I treated them like stems, first glazing over with water and then running the paint down the edges with a fine brush, leaving a highlight down the middle. When I had finished putting in details such as the tiny hairs, I added more depth to the painting by darkening the roots at the back with French Ultramarine and emphasizing those in the foreground with warmer tints of Yellow Ochre and Cadmium Orange.

I had completed my preliminary work and the time had come to begin the finished painting. I made some pencil sketches and used tracings to plan the composition. I began reproducing the root system and the grey-green sheaths at the base of the stems. Wondering where to go next, I decided to make a pencil drawing of a leaf, which I traced so I could see how it fitted into the composition. I wanted to show the back of a second leaf, so I made another quick sketch on tracing paper to give me a sense of the proportions before I began painting.

When the two leaves were completed I began painting the flowers. Remembering my tutor's criticism of my first assignment, I took great care with the details of the stamens and carpels. After studying the structures with a magnifying lens, I drew them as precisely as I could and then picked them out carefully using a fine brush.

Above: Christmas rose buds.
Overleaf: Christmas rose leaves and flowers; Christmas rose roots.

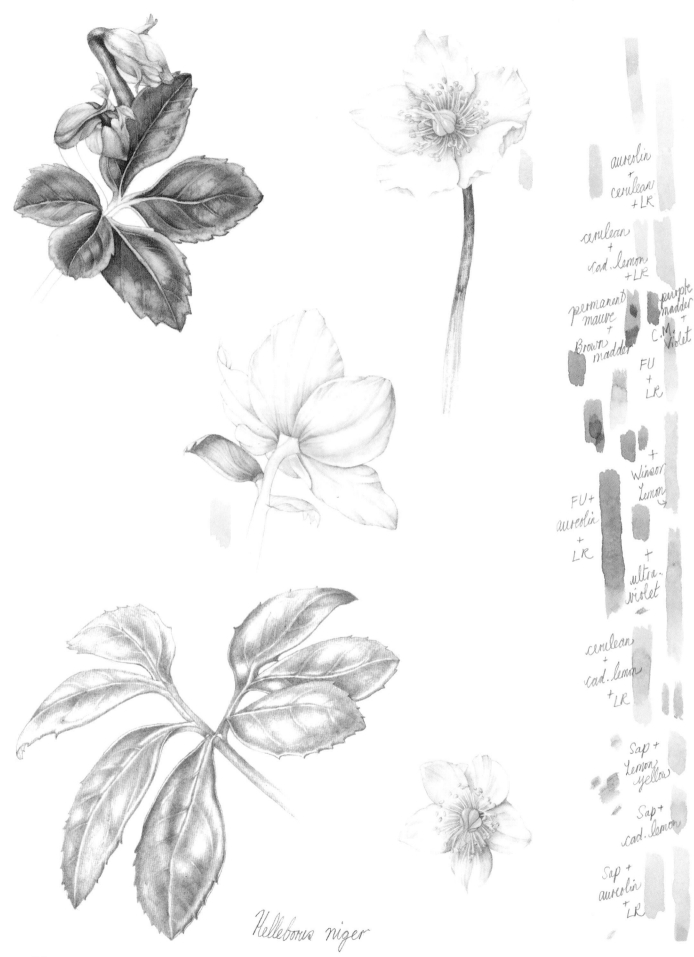

aureolin
+
cerulean
+LR

cerulean
+
cad. lemon
+LR

permanent
mauve
+
Brown
madder

purple
madder
+
violet

C.M.

FU
+
LR

FU+
aureolin
+
LR

Winsor
Lemon

+
ultra..
violet

cerulean
+
cad. lemon
+LR

Sap +
Lemon
yellow

Sap +
cad. lemon

Sap +
aureolin
+
LR

Helleborus niger

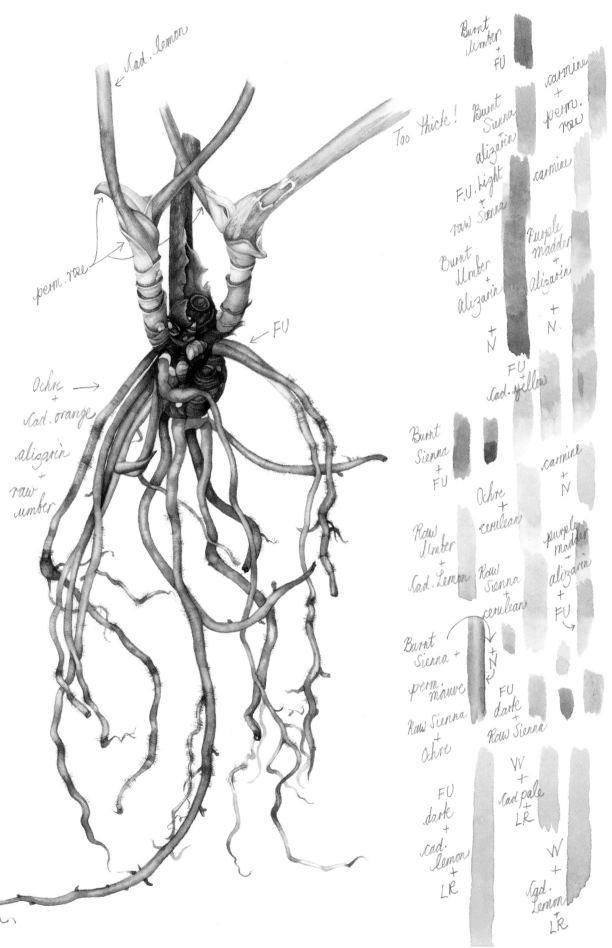

Cad. Lemon

perm. rose

FU

Ochre
+
Cad. orange

alizarin
+
raw
umber

Too thick !

Burnt
Umber
+
FU

Burnt
Sienna
+
alizarin

F.U. light
+
raw Sienna

Burnt
Umber
+
Alizarin
+
N.

FU
+
Cad. yellow

carmine
+
perm.
rose

carmine

Purple
madder
+
alizarin
+
N.

Burnt
Sienna
+
FU

Raw
Umber
+
Cad. Lemon

Ochre
+
cerulean

Raw
Sienna
+
cerulean

carmine
+
N.

purple
madder
+
alizarin
+
FU

Burnt
Sienna +
perm.
mauve

Raw Sienna
+
Ochre

FU +
N.

FU
dark
+
Raw Sienna

FU
dark
+
cad.
lemon
+
LR

VV
+
cad pale
+
LR

VV
+
Cad.
Lemon
+
LR

showing back

pencil

Turpin → dissections

More green around corolla flower (left).
Tidy up anthers / filaments
Finish stem

Above, left and below: Christmas rose:
composition and dissection sketches.
Right: The final assignment:
Christmas rose.

 ×2

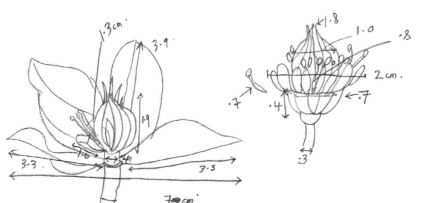

1. CARPEL AND ANTHER

2. CARPEL, STAMENS AND NECTARIES.

3. COROLLA, DISSECTION

4. OVARY

5. OVARY, DISSECTION SHOWING SEEDS

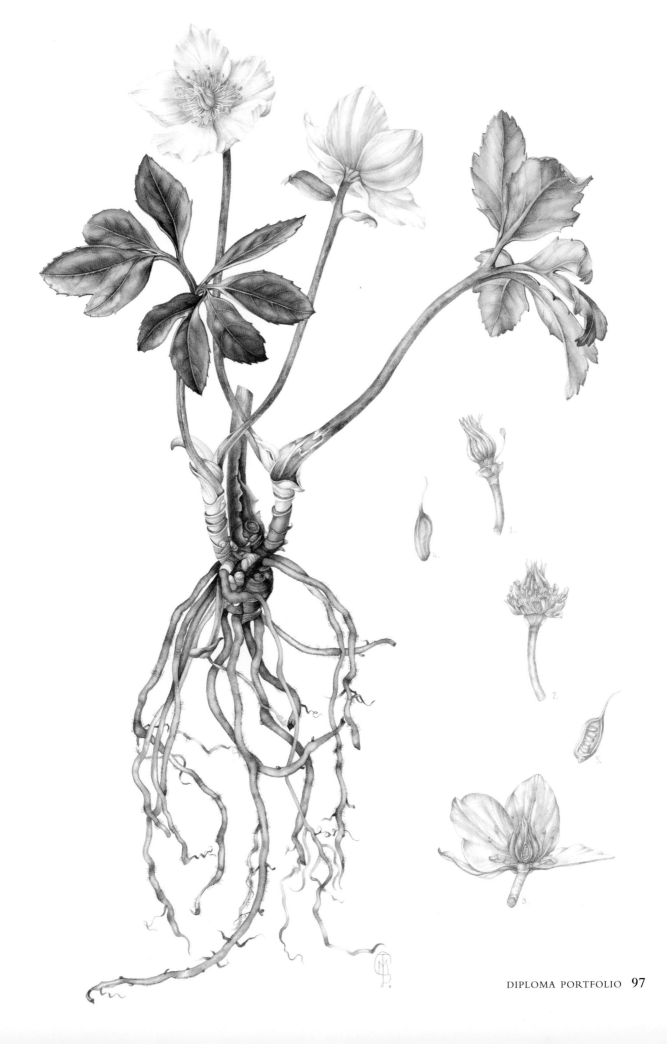

MIXED COMPOSITION

I had left Part 3 until last, calculating that at the end of the winter a wider choice of plants would be available. *Camellia sasanqua* 'Yuletide', which had displayed its jewel-like flowers all through the grey winter months, was now at the end of its flowering season. I made some sketches, trying to capture the glowing colour with a mix of Winsor Red and Alizarin Crimson.

The submission date was rapidly approaching and I had to make some quick decisions without spending much time on preparatory sketches. *Helleborus orientalis* was in full bloom and the irresistible *Camellia japonica* 'Hagoromo' was just coming into flower. I had tried painting both these plants earlier in the course and a glance back through my sketchbook gave me some indications of the colour mixes I could use.

I was happy with my sketch of the camellia's open bloom and decided to copy it for the finished painting. Learning from previous experience, I avoided using grey tints in the shadows; as shadows often have a purple content I blended in a little Ultramarine Violet or deepened the pink tone to give depth where needed. The dark, glossy leaves and stems were placed around the flower to provide a frame for the petals. I began painting the fat pink buds and the leaves, leaving the stems lightly sketched in pencil. The sepals were covered in tiny silky hairs and I imitated their texture using light, feathery strokes with a dry brush.

Below: Camellia 'Hagoromo'.

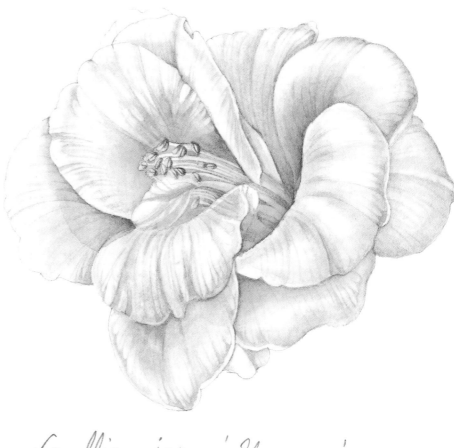

Camellia jap. 'Hagoromo'

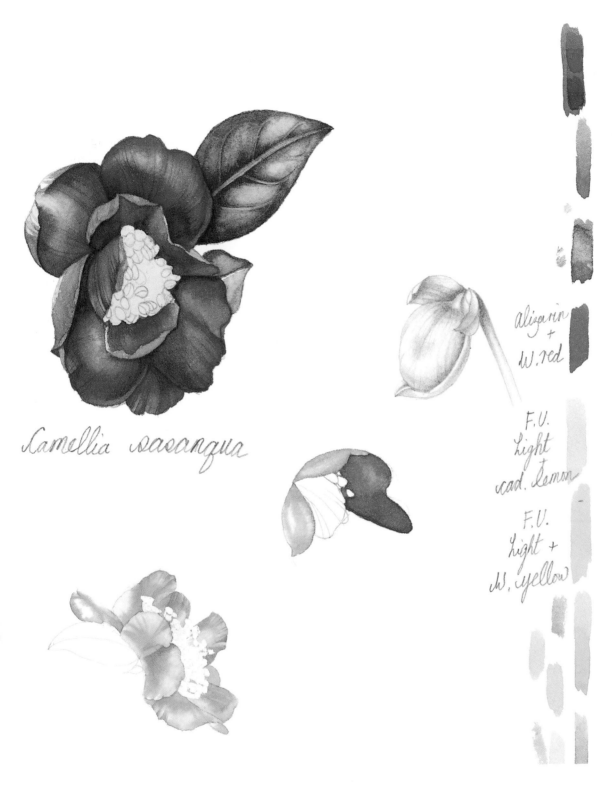

Camellia sasanqua

alizarin
+
W. red

F.V.
Light
cad. lemon

F.V.
Light +
W. yellow

The dark purple Christmas rose complemented the colour of the camellia beautifully and when I had painted three stems with flowers and buds I decided not to disturb the balance of pink, purple and green by adding other flowers. A basic mix of Winsor Violet and Cadmium Red caught the subdued shades of mauve to perfection and the addition of a little Neutral (see page 127) made a good shadow tint. The different nuances of colour where the petals curved towards or away from the light were shown with glazes of Cobalt Blue, Permanent Rose and Quinacridone Magenta.

Above: Camellia sasanqua *'Yuletide'.*

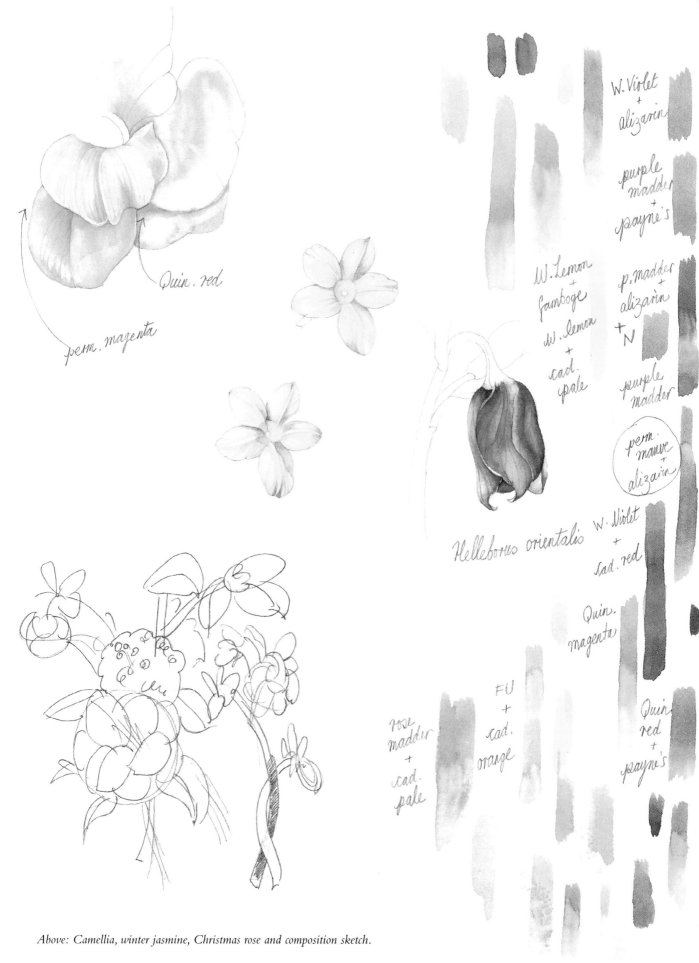

Quin. red

perm. magenta

W. Violet
+
alizarin

purple
madder
+
payne's

W. Lemon
+
gamboge
W. lemon
+
cad.
pale

p. madder
+
alizarin
+
N

purple
madder

perm.
mauve
+
alizarin

Helleborus orientalis

W. Violet
+
cad. red

Quin.
magenta

rose
madder
+
cad.
pale

FU
+
cad.
orange

Quin.
red
+
payne's

Above: Camellia, winter jasmine, Christmas rose and composition sketch.

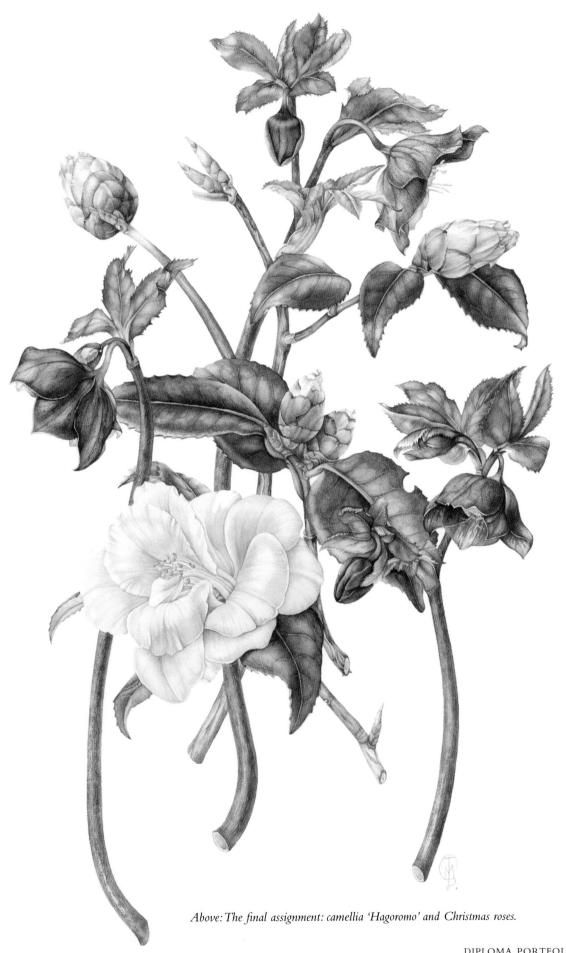

Above: The final assignment: camellia 'Hagoromo' and Christmas roses.

TUTOR'S COMMENTS

As I had broken my wrist I was unable to write anything when judging took place and others wrote to my dictation so of necessity I kept it short. Here are the complete comments from myself and Victoria Matthews BSc. FLS Dip Tax, the botanist who marks for botanical accuracy.

Part 1
A String of Red Onions
MS: This painting has been coveted by all who have seen it. Congratulations on a remarkable result.
VM: Exceptional observation. A top mark of 25 per cent.

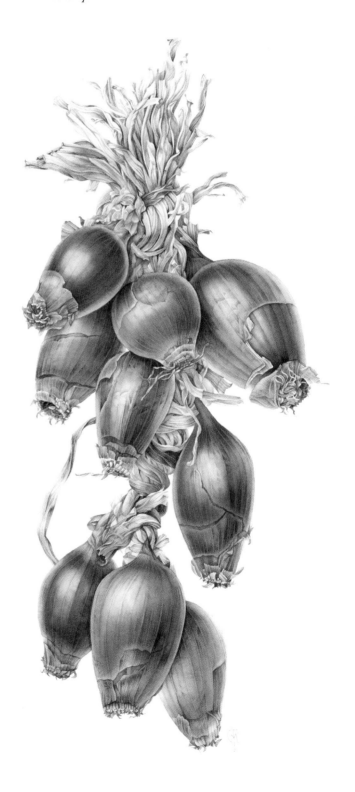

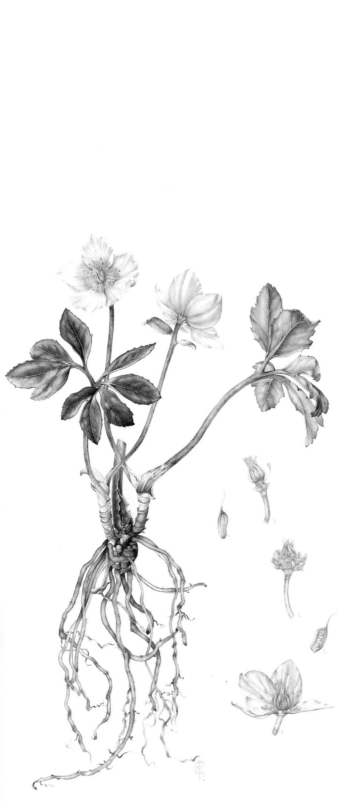

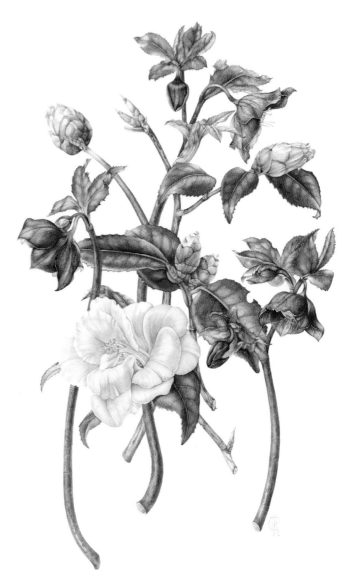

Part 3
Camellia japonica 'Hagaromo'
and *Helleborus orientalis*
MS: I might have chosen a
camellia with a less awkward
perspective but yours suits the
space available! Another
excellent result.
VM: Very well observed,
although a pity there is no
'face-on' hellebore.
Another top mark of 25 per
cent.

Part 2
Helleborus niger
MS: Wonderful!
VM: Very good observation.
Excellent dissection.
A top mark of 25 per cent.

Moving On

From a moderate start, when a discouraged Mary Ann came close to giving up, to a truly magnificent finish. The final set of perfect marks gave her a total of 186 out of 200, which converted to 93% and a Diploma with Distinction. There can only be one lesson to learn from this, apart from the artistic ones, and that is to stick with it. By not taking the easy option of pulling out, Mary Ann has built a firm foundation on which I am positive her artistic career will flourish. I wish her every success in the years to come.

And then... Mary Ann became a Member of the SBA and she was invited to submit work to the prestigious Institute of Botanical Documentation at Carnegie Mellon University, Pittsburgh, USA.

It was good to discover that she continued to devote time to painting once she had completed the course. New sketchbooks were started and pages from these, together with recent paintings, follow.

Margaret Stevens

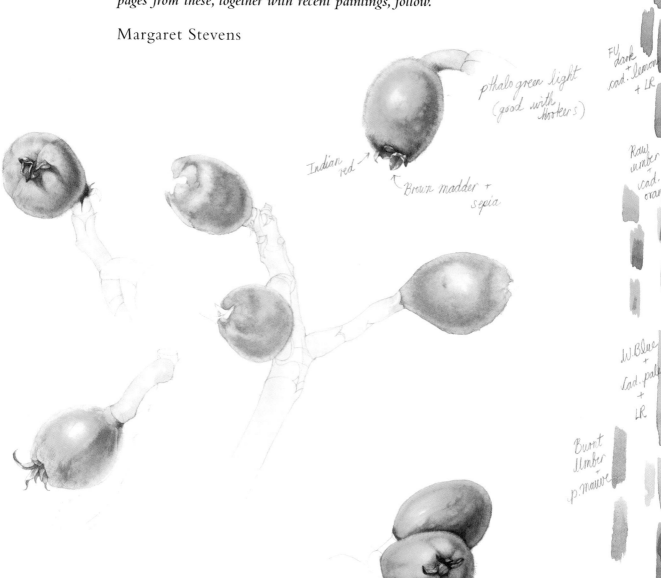

pthalo green light
(good with Hookers)

Indian red

Brown madder + sepia

FU dark
cad. + lemon
+ LR

Raw umber
+
cad. orange

W. Blue
+
cad. pale
+
LR

Burnt umber
+
p. mauve

Mary Ann Scott: Once the course was over I was free to paint whatever I wished without the constraints of fixed assignments and deadlines. I decided to continue to keep a sketchbook as I found this way of working both productive and enjoyable. My sketchbook was a place where I could experiment with colour, form and texture, try out new techniques, plan compositions or just play around with ideas. During the course I had made copious colour notes, and now I decided to sort them out and make more colour charts, which would be useful as a reference tool, saving time when I needed to match a particular colour. The following pages are from my later, post-course sketchbook, together with the paintings that evolved from the sketches.

Opposite page: Unripe loquat fruit.
Below: Loquat fruit dissection and seeds.

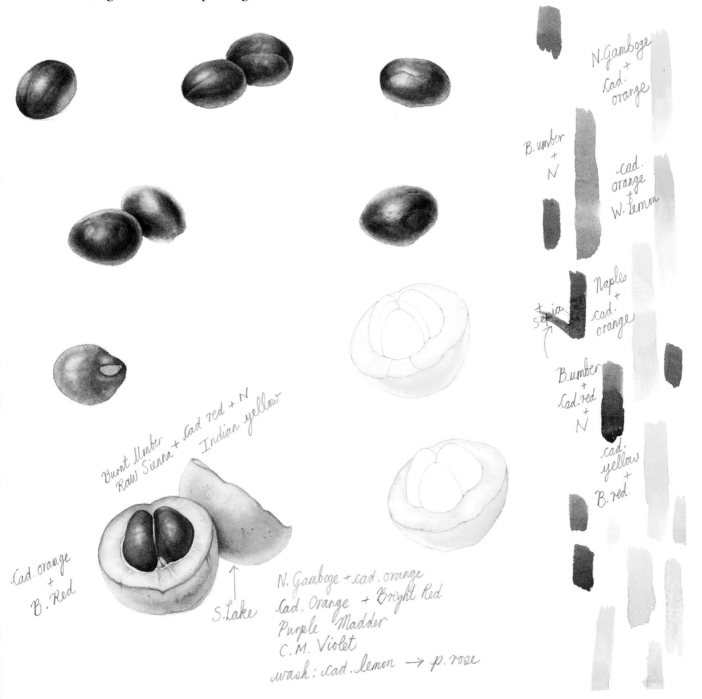

Burnt Umber + Cad red + N
Raw Sienna + Indian yellow

Cad. orange + B. Red

S. Lake

N. Gamboge + cad. orange
Cad. Orange + Bright Red
Purple Madder
C. M. Violet
wash: cad. lemon → p. rose

N. Gamboge + Cad. orange

B. umber + N

cad. orange + W. Lemon

Naples + cad. orange

sepia

B. umber + Cad. red + N

cad. yellow + B. red.

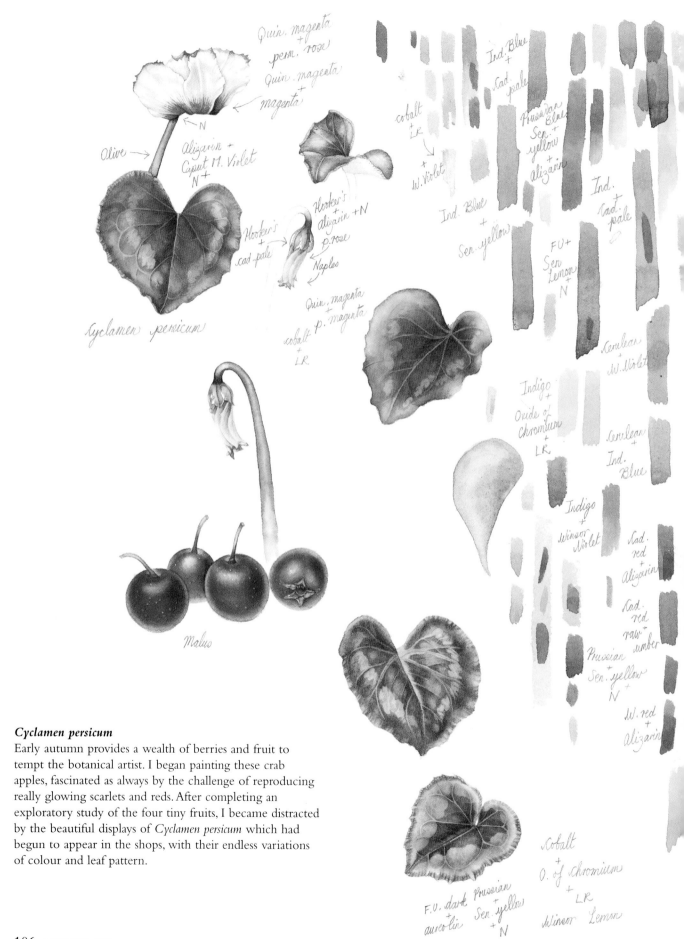

Cyclamen persicum

Early autumn provides a wealth of berries and fruit to tempt the botanical artist. I began painting these crab apples, fascinated as always by the challenge of reproducing really glowing scarlets and reds. After completing an exploratory study of the four tiny fruits, I became distracted by the beautiful displays of *Cyclamen persicum* which had begun to appear in the shops, with their endless variations of colour and leaf pattern.

I was particularly attracted to this variety of *Cyclamen persicum* because of its beautiful leaf markings. Variegated leaves can often be challenging to paint, but here I was helped by the neat contrast between the soft pewter grey on the outside of the leaves and the dark bottle green bordering the main veins. The pure white flowers were subtly flushed with pink reflections, while the petals were edged with a deeper pink, which I painted with a mix of Quinacridone Magenta and Permanent Rose, which helped to emphasize the elegant form. The neatly furled buds were also delightful, reminding me of tiny parasols.

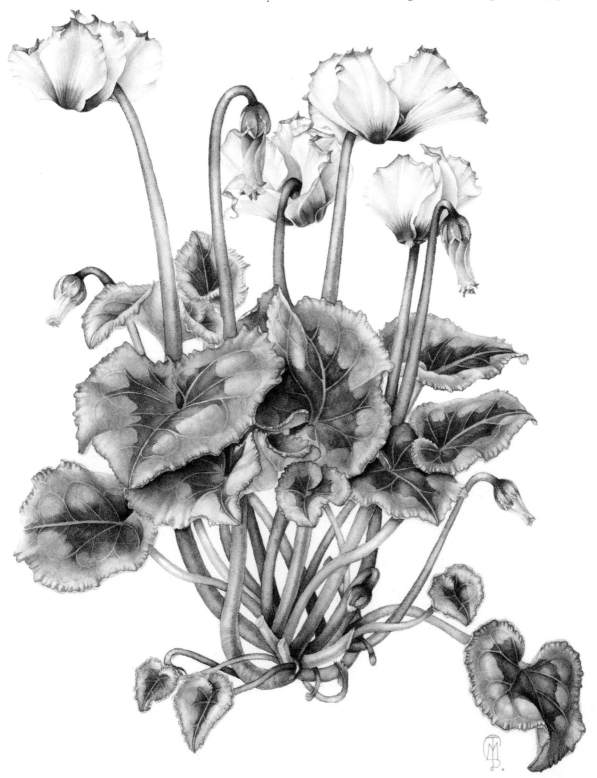

Camellia japonica 'General Colletti'

I had enjoyed painting the pink and white blooms of *Camellia* 'Bonomiana' for Assignment 7, and when I found the historic *Camellia japonica* 'General Colletti' on my Saturday morning foray to the market I knew I had to paint it! Unlike the clearly delineated streaks on the *C.* 'Bonomiana', the variegated petals of 'General Colletti' presented a more blurred impression which could be shown by laying washes wet-on-wet, allowing the mix of Quinacridone Red and Winsor Red to flow into the areas of white, leaving soft, unfocused edges.

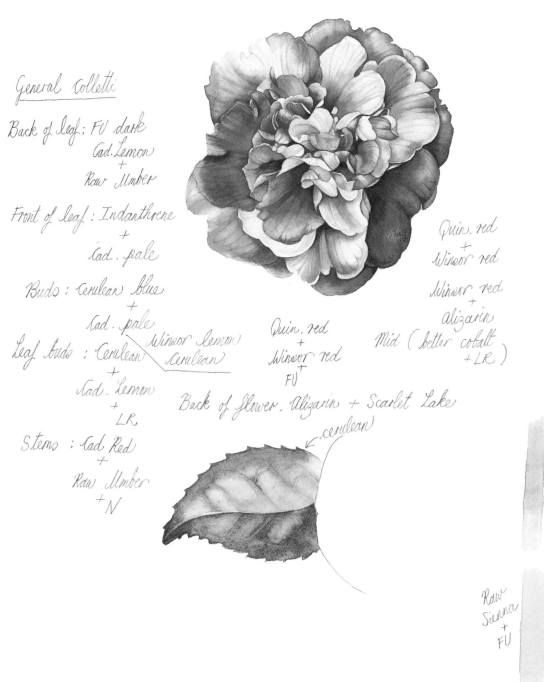

General Colletti

Back of leaf: FU dark
 Cad. Lemon
 +
 Raw Umber

Front of leaf: Indanthrene
 +
 Cad. pale

Buds: Cerulean Blue
 +
 Cad. pale

Leaf Buds: Cerulean Winsor lemon
 + Cerulean
 Cad. Lemon
 +
 LR

Stems: Cad Red
 +
 Raw Umber
 + N

Quin. red
 +
Winsor red
 +
FU

Back of flower. Alizarin + Scarlet Lake

← cerulean

Quin. red
 +
Winsor red

Winsor red
 +
Alizarin

Mid (better cobalt
 + LR)

Quin. red
 +
Winsor red

Alizarin
 +
Winsor red

Raw Sienna
 +
FU

FU +
Cad. lemon
 +
Raw Umber

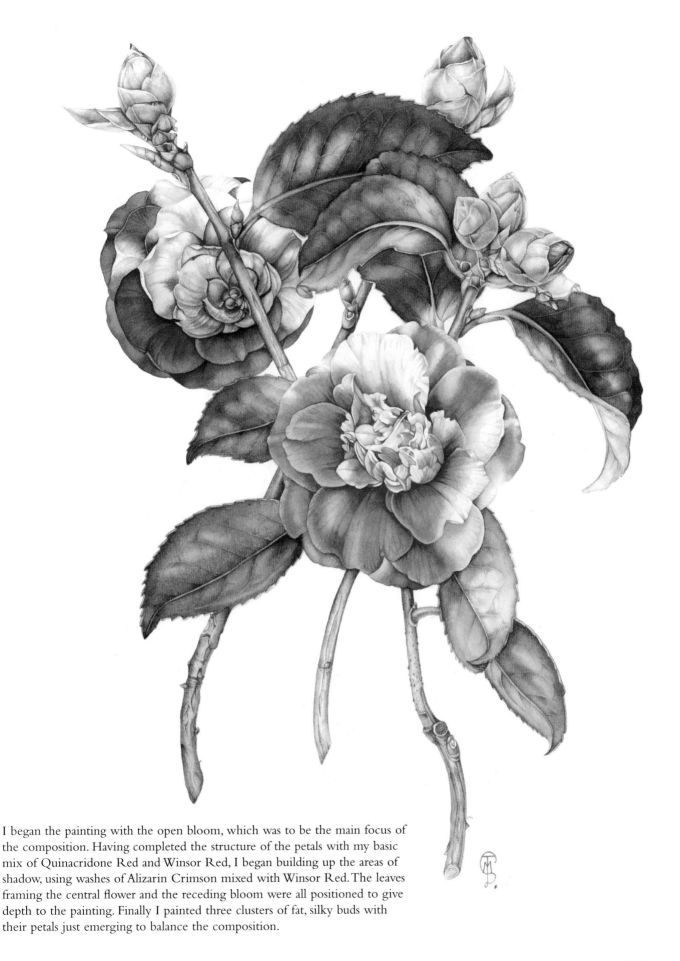

I began the painting with the open bloom, which was to be the main focus of the composition. Having completed the structure of the petals with my basic mix of Quinacridone Red and Winsor Red, I began building up the areas of shadow, using washes of Alizarin Crimson mixed with Winsor Red. The leaves framing the central flower and the receding bloom were all positioned to give depth to the painting. Finally I painted three clusters of fat, silky buds with their petals just emerging to balance the composition.

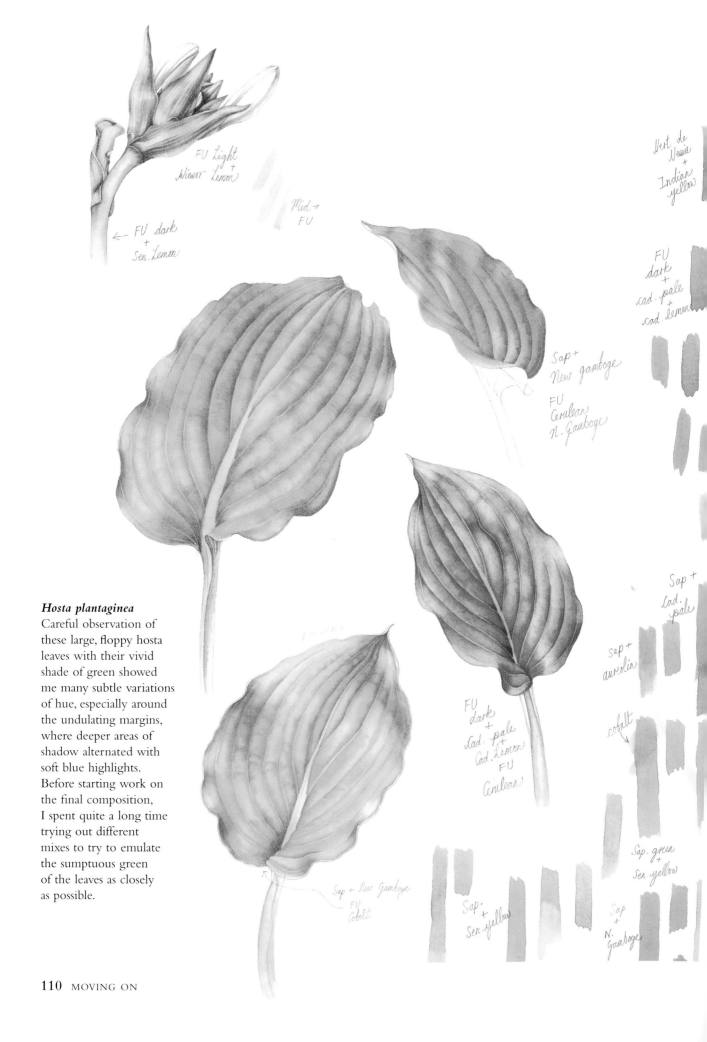

FU Light
+
Winsor Lemon)

Mid +
FU

← FU dark
+
Ser. Lemon

Vert de
Nessie
+
Indian
yellow

FU
dark
+
cad. pale
+
cad. lemon

Sap +
New gamboge

FU
Cerulean
N. Gamboge

Sap +
cad.
pale

Sap +
aureolin

cobalt

Hosta plantaginea
Careful observation of
these large, floppy hosta
leaves with their vivid
shade of green showed
me many subtle variations
of hue, especially around
the undulating margins,
where deeper areas of
shadow alternated with
soft blue highlights.
Before starting work on
the final composition,
I spent quite a long time
trying out different
mixes to try to emulate
the sumptuous green
of the leaves as closely
as possible.

FU
dark
+
cad. pale
+
Cad. Lemon
FU
Cerulean

Sap. green
+
Ser. yellow

Sap + New Gamboge
FU
Cobalt.

Sap.
+
Ser. yellow

Sap
+
N.
Gamboge

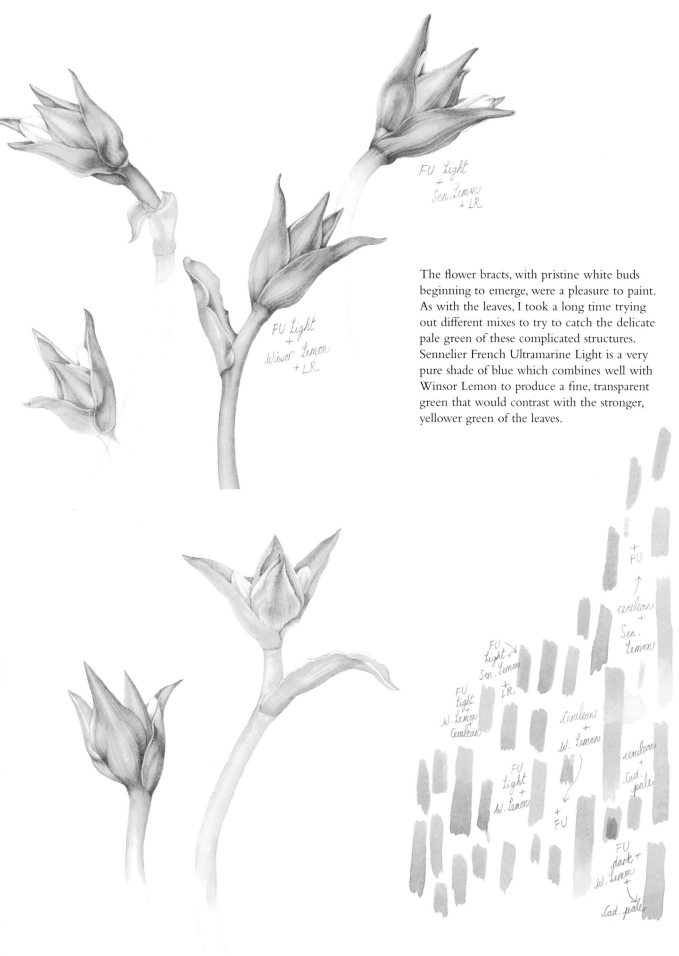

FU Light
+
Sen. Lemon
+ LR

FU Light
+
Winsor Lemon
+ LR

The flower bracts, with pristine white buds beginning to emerge, were a pleasure to paint. As with the leaves, I took a long time trying out different mixes to try to catch the delicate pale green of these complicated structures. Sennelier French Ultramarine Light is a very pure shade of blue which combines well with Winsor Lemon to produce a fine, transparent green that would contrast with the stronger, yellower green of the leaves.

+
FU

cerulean
+
Sen.
Lemon

FU
Light
+
Sen. Lemon

FU
Light
+
W. Lemon +
Cerulean

+
LR

cerulean
+
W. Lemon

cerulean
+
Cad.
pale

FU
Light
+
W. Lemon

+
FU

FU
dark +
W. Lemon
+
Cad. pale

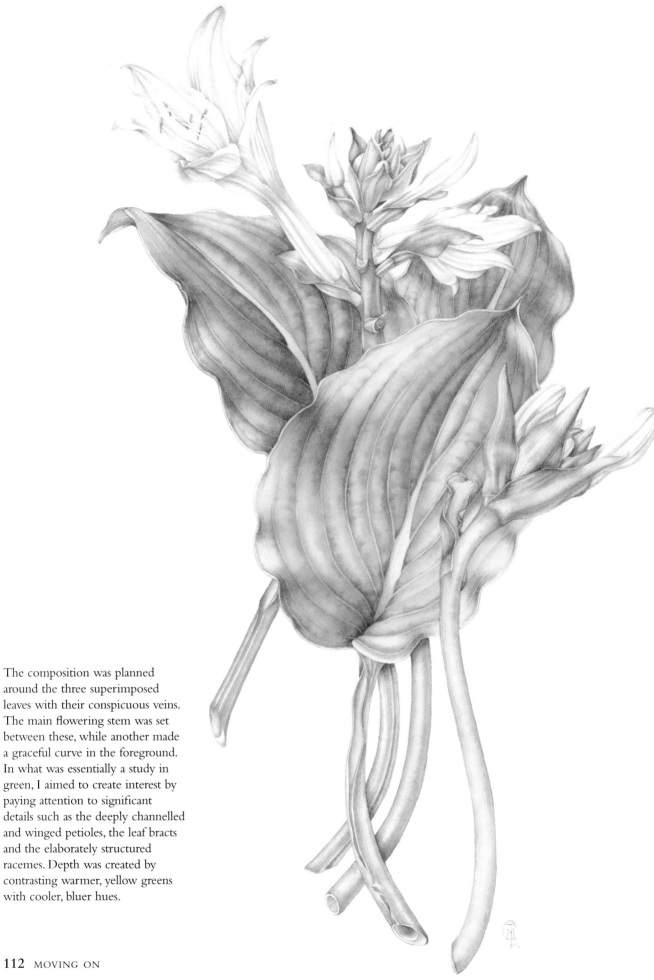

The composition was planned around the three superimposed leaves with their conspicuous veins. The main flowering stem was set between these, while another made a graceful curve in the foreground. In what was essentially a study in green, I aimed to create interest by paying attention to significant details such as the deeply channelled and winged petioles, the leaf bracts and the elaborately structured racemes. Depth was created by contrasting warmer, yellow greens with cooler, bluer hues.

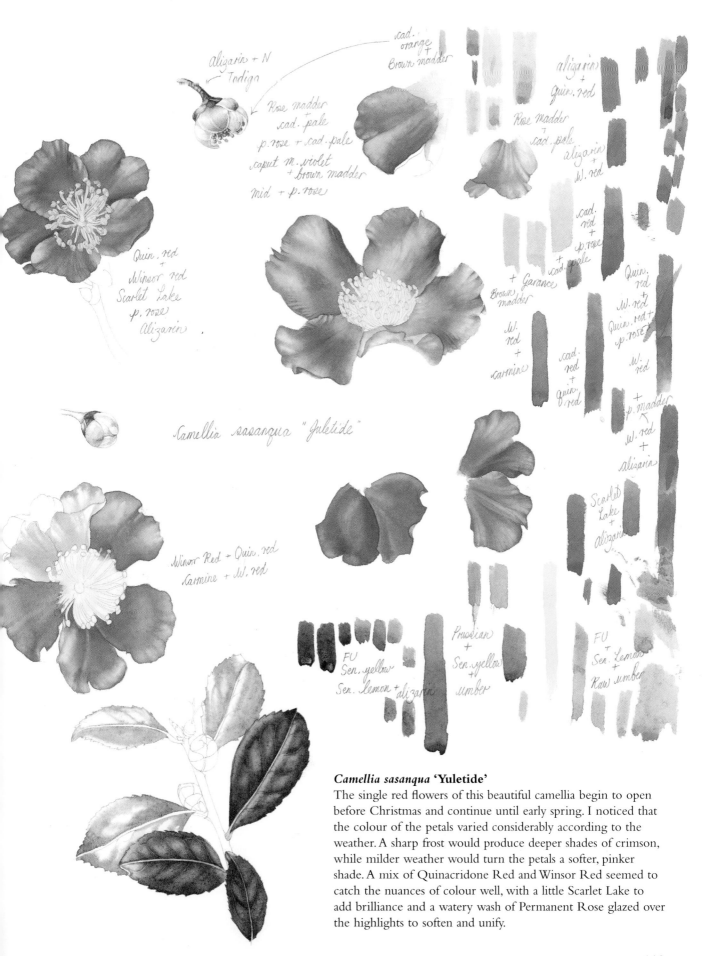

Alizarin + N Indigo

cad. orange + Brown madder

Rose madder + cad. pale

p. rose + cad. pale

caput m. violet + brown madder

mid + p. rose

Quin. red + Winsor red Scarlet Lake p. rose Alizarin

alizarin + Quin. red

Rose madder + cad. pale

alizarin + W. red

cad. red + p. rose + cad. pale

+ Garance

Brown madder

W. red + carmine

cad. red + quin. red

Quin. red

W. red + Quin. red + p. rose

W. red + p. madder

W. red + alizarin

Scarlet Lake + Alizarin

Camellia sasanqua "Yuletide"

Winsor Red + Quin. red Carmine + W. red

FU Sen. yellow Sen. lemon + alizarin

Prussian + Sen. yellow + umber

FU + Sen. Lemon + Raw umber

Camellia sasanqua 'Yuletide'

The single red flowers of this beautiful camellia begin to open before Christmas and continue until early spring. I noticed that the colour of the petals varied considerably according to the weather. A sharp frost would produce deeper shades of crimson, while milder weather would turn the petals a softer, pinker shade. A mix of Quinacridone Red and Winsor Red seemed to catch the nuances of colour well, with a little Scarlet Lake to add brilliance and a watery wash of Permanent Rose glazed over the highlights to soften and unify.

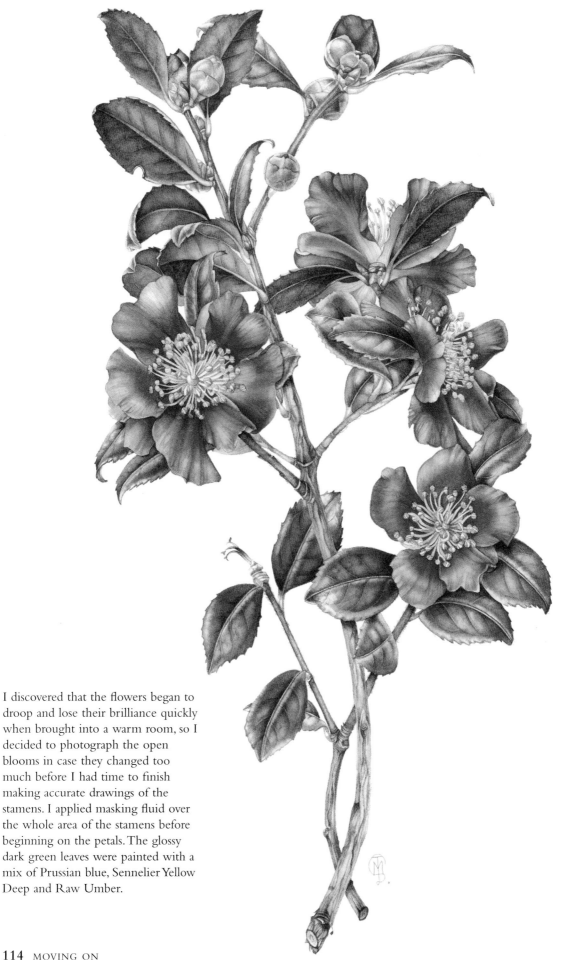

I discovered that the flowers began to droop and lose their brilliance quickly when brought into a warm room, so I decided to photograph the open blooms in case they changed too much before I had time to finish making accurate drawings of the stamens. I applied masking fluid over the whole area of the stamens before beginning on the petals. The glossy dark green leaves were painted with a mix of Prussian blue, Sennelier Yellow Deep and Raw Umber.

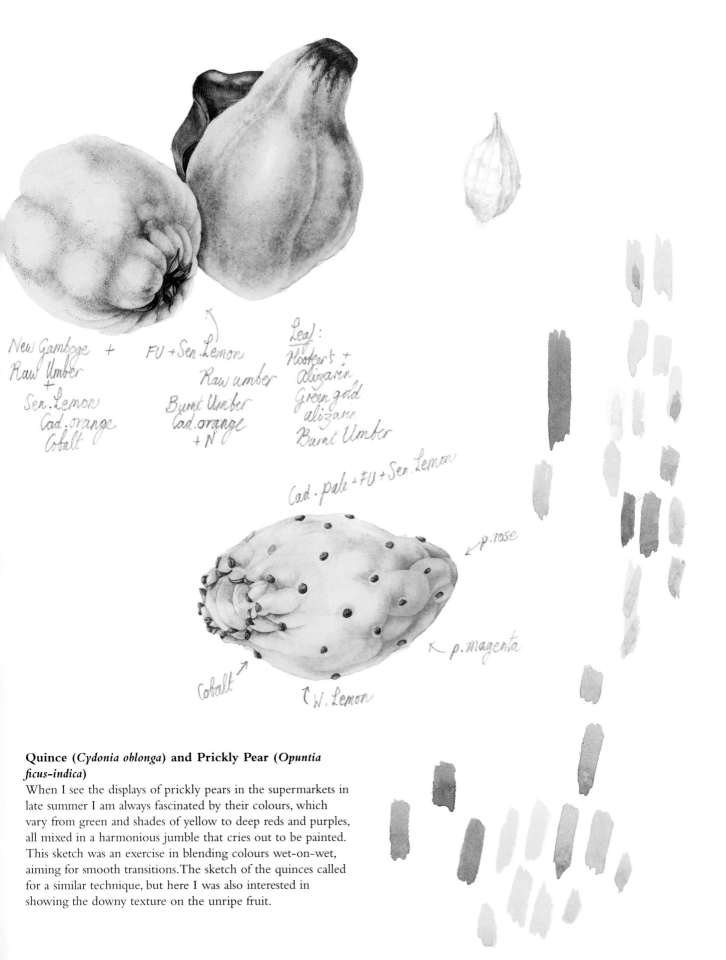

New Gamboge +
Raw Umber
+
Sen. Lemon
Cad. orange
Cobalt

FU + Sen. Lemon
Raw umber
Burnt Umber
Cad. orange
+ N

Leaf:
Hooker's +
alizarin
Green gold
alizarin
Burnt Umber

Cad. pale + FU + Sen. Lemon

p. rose

p. magenta

Cobalt

W. Lemon

Quince (*Cydonia oblonga*) and Prickly Pear (*Opuntia ficus-indica*)

When I see the displays of prickly pears in the supermarkets in late summer I am always fascinated by their colours, which vary from green and shades of yellow to deep reds and purples, all mixed in a harmonious jumble that cries out to be painted. This sketch was an exercise in blending colours wet-on-wet, aiming for smooth transitions. The sketch of the quinces called for a similar technique, but here I was also interested in showing the downy texture on the unripe fruit.

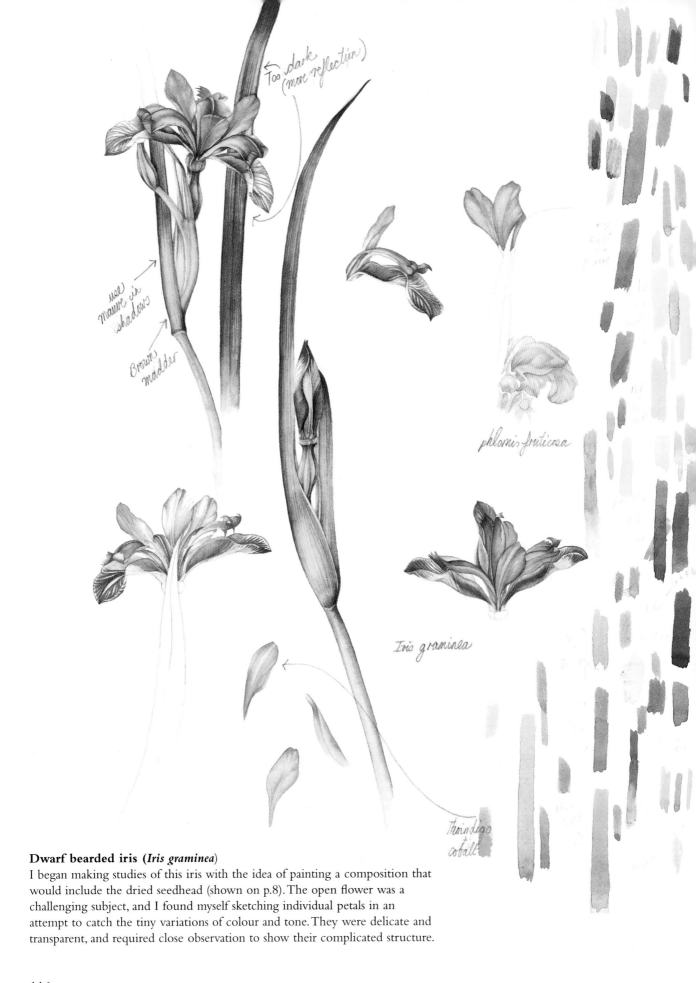

Too dark (more reflection)

use mauve in shadows

Brown madder

phlomis fruticosa

Iris graminea

Thio indigo cobalt

Dwarf bearded iris (*Iris graminea*)
I began making studies of this iris with the idea of painting a composition that would include the dried seedhead (shown on p.8). The open flower was a challenging subject, and I found myself sketching individual petals in an attempt to catch the tiny variations of colour and tone. They were delicate and transparent, and required close observation to show their complicated structure.

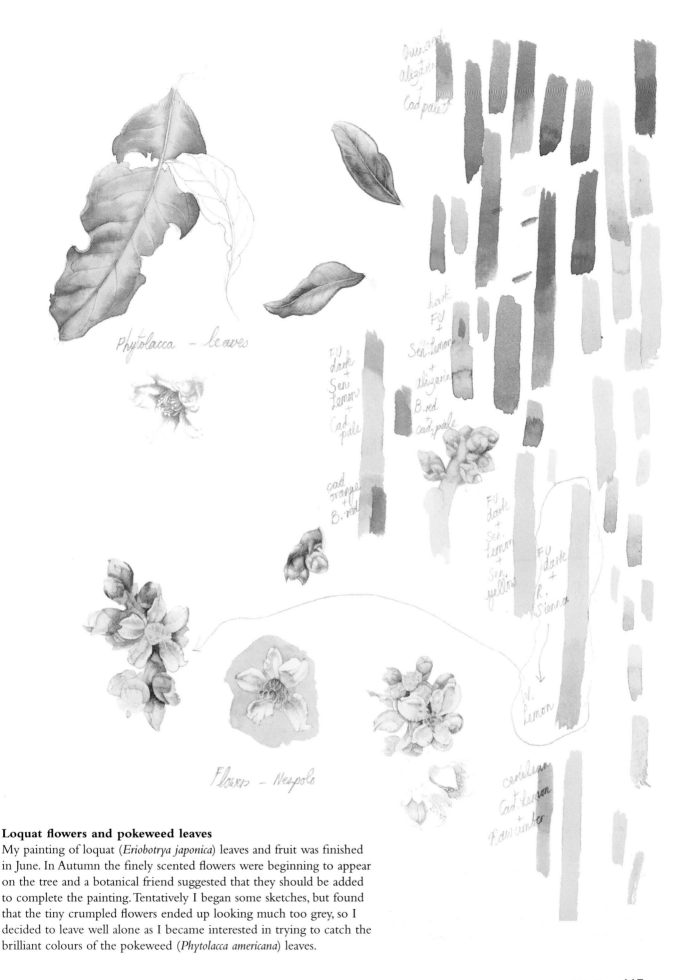

Phytolacca – leaves

Flowers – Nespolo

Loquat flowers and pokeweed leaves

My painting of loquat (*Eriobotrya japonica*) leaves and fruit was finished
in June. In Autumn the finely scented flowers were beginning to appear
on the tree and a botanical friend suggested that they should be added
to complete the painting. Tentatively I began some sketches, but found
that the tiny crumpled flowers ended up looking much too grey, so I
decided to leave well alone as I became interested in trying to catch the
brilliant colours of the pokeweed (*Phytolacca americana*) leaves.

Cape Gooseberry and magnolia seedhead

The seedhead of *Magnolia grandiflora* (bottom left) was a really attractive subject.
I loved its soft, felty texture and the way the colour moved from a greenish
yellow to warm shades of Scarlet Lake and Vermillion. The opening seed capsules
were given depth with dark tones of Sepia mixed with Neutral (see page 127),
accentuating the bright red berries. The cape gooseberry (*Physalis peruviana*),
shown top left, was an interesting exercise in texture; it was useful to observe
how the fruit showed through the fine, lacy texture of the dried petals.

cobalt
+
aurelin + LR
scarlet lake + ochre

B. Umber + FU

Sepia + N
C.M. Violet + N

Scarlet Lake + S. vermillion

shadow - cobalt, aurelin + N + FU
washes - W. Lemon
 Raw Sienna
Berries - Cad Red + W. red
 B. red
 Alizarin

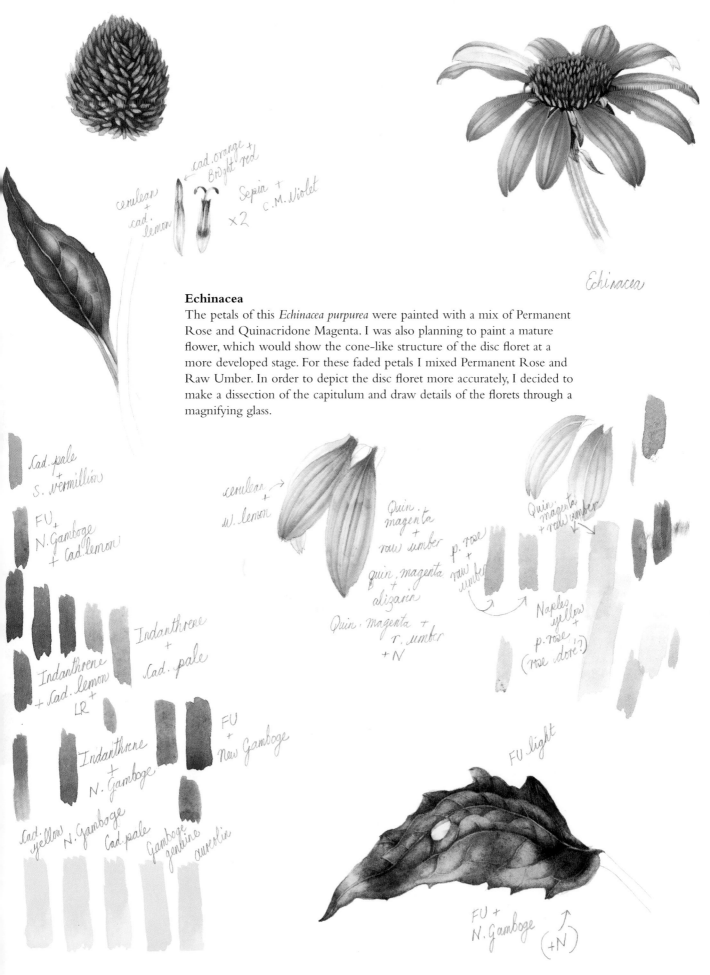

Echinacea

The petals of this *Echinacea purpurea* were painted with a mix of Permanent Rose and Quinacridone Magenta. I was also planning to paint a mature flower, which would show the cone-like structure of the disc floret at a more developed stage. For these faded petals I mixed Permanent Rose and Raw Umber. In order to depict the disc floret more accurately, I decided to make a dissection of the capitulum and draw details of the florets through a magnifying glass.

Loquat fruits, *Clematis viticella* and French lavender

I experimented with several mixes of pink, red and violet before begining on the clematis, whose petals seem to shimmer with layers of colour. The French lavender (*Lavandula stoechas*) was painted with a mix of Cobalt Blue and Permanent Rose which was gradually blended into a greyish green consisting of Cobalt Blue and Aureolin with a little Light Red. I then turned my attention to the fruit of the Japanese loquat, which were ripening on the tree outside my studio window.

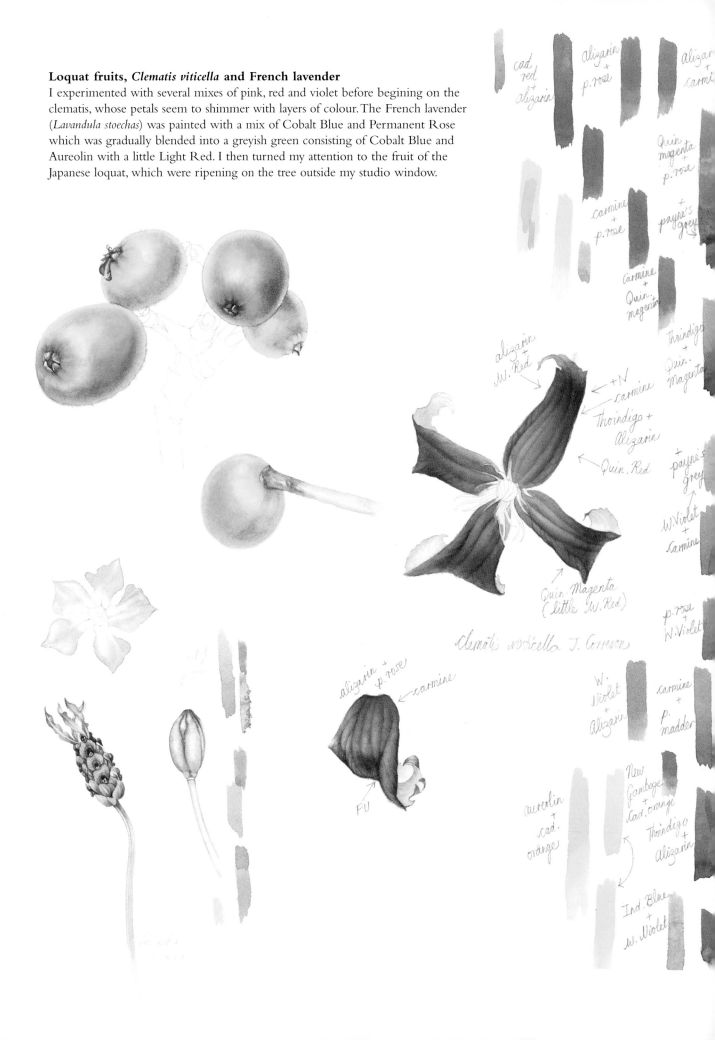

cad. red + alizarin

alizarin + p.rose

alizarin + carmi

Quin magenta + p.rose

carmine + p.rose

payne's grey

Carmine + Quin magenta

Thoindigo + Quin. Magenta

alizarin + W. Red

+ N carmine

Thoindigo + Alizarin

Quin. Red

payne's grey

W.Violet + Carmine

Quin. Magenta (little W.Red)

Clematis viticella J. Gossie

p.rose + W.Violet

alizarin + p.rose

carmine

FU

W. Violet + Alizarin

carmine + P. madder

New Gamboge + cad. orange

Thoindigo + alizarin

aureolin + cad. orange

Ind. Blue + W. Violet

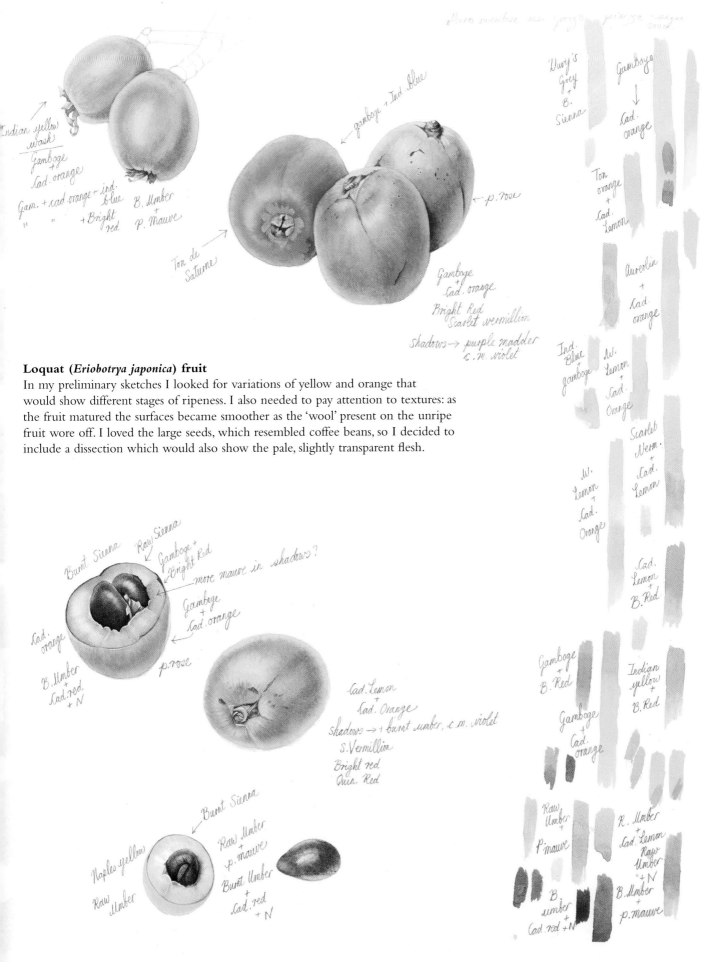

Loquat (*Eriobotrya japonica*) fruit

In my preliminary sketches I looked for variations of yellow and orange that would show different stages of ripeness. I also needed to pay attention to textures: as the fruit matured the surfaces became smoother as the 'wool' present on the unripe fruit wore off. I loved the large seeds, which resembled coffee beans, so I decided to include a dissection which would also show the pale, slightly transparent flesh.

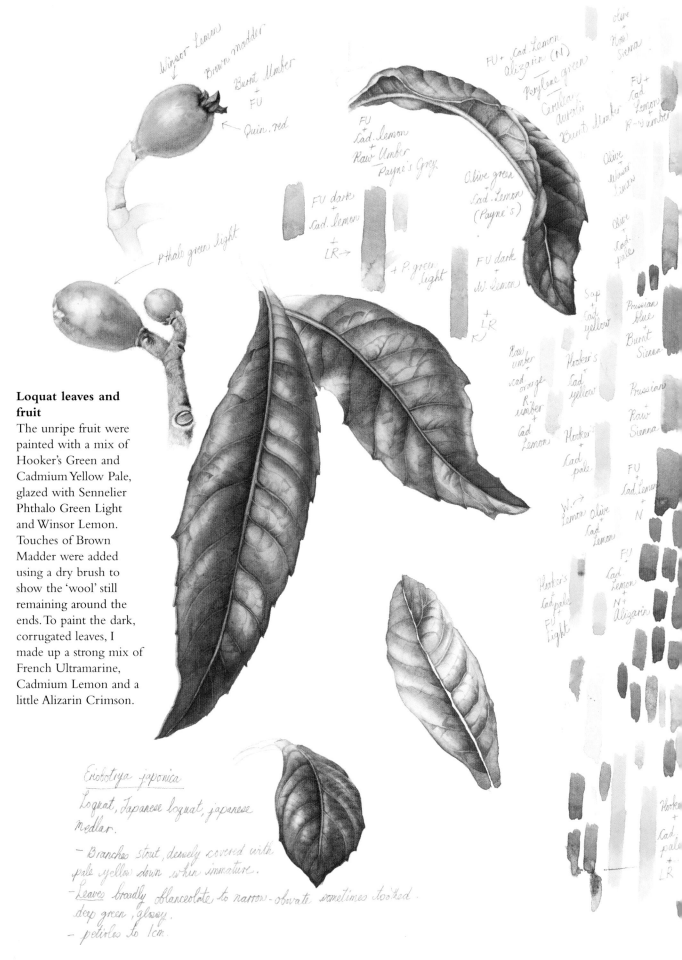

Loquat leaves and fruit

The unripe fruit were painted with a mix of Hooker's Green and Cadmium Yellow Pale, glazed with Sennelier Phthalo Green Light and Winsor Lemon. Touches of Brown Madder were added using a dry brush to show the 'wool' still remaining around the ends. To paint the dark, corrugated leaves, I made up a strong mix of French Ultramarine, Cadmium Lemon and a little Alizarin Crimson.

Quince and rosebuds

To paint the quince I blended yellow into green, as I had done in the sketch on page 115. When the first layers of colour were dry I 'stroked' on some Burnt Umber with a dry brush to show the down and to accentuate some of the bulges. The withered leaf was painted with a mix of Vandyke Brown and Sennelier Cadmium Red. I began sketching details of a *Rosa mutabilis* growing in my garden, thinking that the soft shades of pink and yellow would make a rewarding subject for a painting.

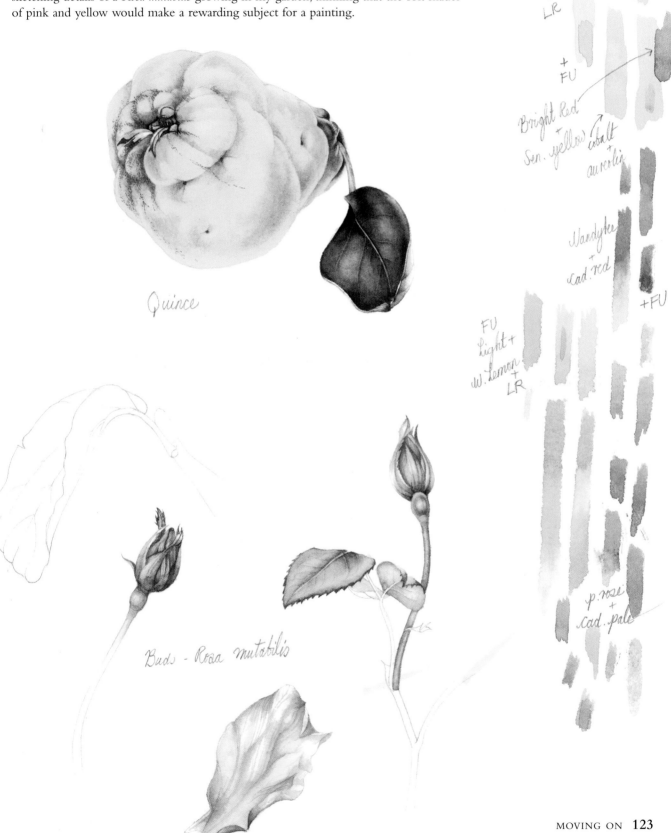

Quince

Buds - Rosa mutabilis

cobalt + aureolin + LR

+ FU

Bright Red + Sen. yellow

cobalt + aureolin

Vandyke + cad. red

+FU

FU Light + W. Lemon + LR

p. rose + cad. pale

Shade Cards

ALIZARIN

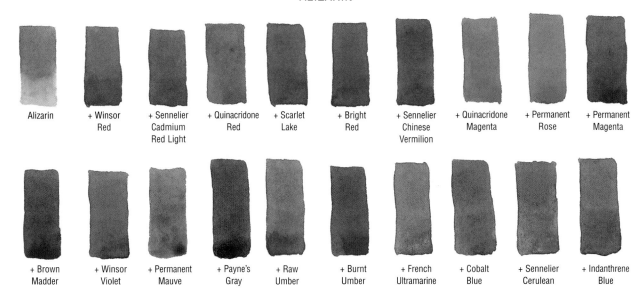

Alizarin | + Winsor Red | + Sennelier Cadmium Red Light | + Quinacridone Red | + Scarlet Lake | + Bright Red | + Sennelier Chinese Vermilion | + Quinacridone Magenta | + Permanent Rose | + Permanent Magenta

+ Brown Madder | + Winsor Violet | + Permanent Mauve | + Payne's Gray | + Raw Umber | + Burnt Umber | + French Ultramarine | + Cobalt Blue | + Sennelier Cerulean | + Indanthrene Blue

PERMANENT ROSE

Permanent Rose | + Quinacridone Magenta | + Ultramarine Violet | + Winsor Violet | + Permanent Mauve | + Permanent Magenta | + Purple Madder | + Alizarin | + Carmine | + Quinacridone Red | + Winsor Red

+ Sennelier Lemon | + Winsor Lemon | + Cadmium Pale | + Sennelier Yellow Deep | + Cadmium Orange | + Raw Sienna | + Raw Umber | + Burnt Umber | + Brown Madder | + Caput Mortuum Violet

NEUTRALS

| Winsor Blue (green) + Bright Red | Winsor Blue (green) + Scarlet Lake | Winsor Blue + Light Red | Indanthrene Blue + Burnt Sienna | French Ultramarine + Cadmium Orange | French Ultramarine + Bright Red | French Ultramarine + Burnt Sienna | French Ultramarine + Burnt Umber | Cobalt Blue + Light Red |

GREYS

| French Ultramarine + Winsor Violet + Cadmium Lemon | French Ultramarine + Winsor Violet + Cadmium Lemon | Cobalt Blue + French Ultramarine | French Ultramarine + Light Red | French Ultramarine + Cadmium Pale + Cadmium Red Mid* | * + Permanent Rose | * + more Cadmium Pale | * + Cerulean Blue + Cadmium Lemon | * + more French Ultramarine | * + Cadmium Orange |

DAVY'S GREY

| Davy's Grey | + Alizarin | + Cadmium Red | + Cadmium Orange | + Cadmium Yellow | + Cadmium Lemon | + Viridian |

| + French Ultramarine | + Cerulean Blue | + Permanent Mauve | + Raw Umber | + Indigo | + Potter's Pink | + Cobalt Blue + Aureolin + Permanent Rose |

RAW UMBER

| Raw Umber | + Alizarin | + Cadmium Red | + Cadmium Orange | + Sennelier Lemon Yellow | + French Ultramarine | + Cerulean Blue | + Permanent Mauve | + Indigo | + Winsor Violet | + N Tint |

BURNT UMBER

| Burnt Umber | + Alizarin | + Cadmium Red | + Cadmium Orange | + Sennelier Lemon | + French Ultramarine | + Cerulean Blue | + Permanent Mauve | + Indigo | + Winsor Violet | + N T |

VANDYKE BROWN

| Vandyke Brown | + Alizarin | + Cadmium Red | + Cadmium Orange | + Sennelier Lemon | + French Ultramarine | + Cerulean Blue | + Indigo | + Winsor Violet | + Neutral Tint |

BURNT SIENNA

| Burnt Sienna | + Alizarin | + Cadmium Red | + Cadmium Orange | + Sennelier Lemon | + French Ultramarine | + Cerulean Blue | + Indigo | + Winsor Violet | + Permanent Magenta | + Ne Ti |

Author's Note: Colour Abbreviations

When I wrote the names of the colours in my sketchbook I used a lot of abbreviations. Some are quite self-explanatory, such as 'cad.' for 'Cadmium'. Others are less obvious, so here's a list:

Cad. pale	Cadmium Yellow Pale
FU	French Ultramarine
Alizarin	Alizarin Crimson
perm. or p.	Permanent
LR	Light Red
Quin.	Quinacridone
W.	Winsor
Sen.	Sennelier
ultra.	Ultramarine
O. of Ch., OOC	Oxide of Chromium
T. Verte	Terre Verte
Ind.	Indanthrene Blue
C. M. Violet	Caput Mortuum Violet
S. Vermillion	Scarlet Vermillion

'Grey' or 'bot. grey' refers to a mix of French Ultramarine and Light Red.

'N' or 'Neutral' is a mix composed of approximately four parts French Ultramarine to one part Permanent Alizarin Crimson, to which Cadmium Yellow is added in small amounts until a dense black appears. I got this 'recipe' from Coral Guest's book *Painting Flowers in Watercolour* (see Bibliography, page 128).

'Mid' refers to a mix of three primary colours which I learned about from reading Billy Showell's Watercolour Flower Portraits (see Bibliography). This blend of two parts French Ultramarine to one part Cadmium Yellow Pale and one part Cadmium Red makes a delicate grey, which can easily be blended with other colours to paint shadows, especially on white flowers.

Unless specified, all the names refer to Winsor & Newton Artists' colours. In the second part of the course I began using Sennelier Aquarelle, gradually substituting them for many of my Winsor & Newton paints. I've found that Sennelier produce many delicate and beautiful shades that are well adapted for botanical paintings, and exceptionally pleasant to use. I particularly like Carmine Genuine, Chinese Vermillion and Cadmium Red Light among the reds, and I've substituted Sennelier Yellow Deep for Winsor & Newton Cadmium Yellow as I find it better to handle and slightly more transparent. Similarly, Sennelier Naples Yellow is a lovely colour to work with. I have three French Ultramarines in my palette, which may sound eccentric, but I find that when mixed with yellow they produce totally different greens. 'FU Light' refers to Sennelier French Ultramarine Light, while 'FU Dark' refers to French Ultramarine Dark.

Bibliography

Blunt, Wilfred and W. T. Stearn. *The Art of Botanical Illustration*. Antique Collector's Club in association with The Royal Botanic Gardens, Kew, 1994

Guest, Coral. *Painting Flowers in Watercolour*. A&C Black, 2001

Sherlock, Siriol. *Botanical Illustration*. Batsford, 2004

Sherwood, Shirley. *Contemporary Botanical Artists.* Weidenfeld & Nicolson, 1996

Sherwood, Shirley, Stephen Harris and Barrie Edward Juniper. *A New Flowering: 1000 Years of Botanical Art*. Ashmolean Museum, Oxford, 2005

Sherwood, Shirley. *A Passion for Plants*. Weidenfeld & Nicolson, 2002

Sherwood, Shirley. *Treasures of Botanical Art*. Royal Botanic Gardens, Kew, 2008

Showell, Billy. *Watercolour Flower Portraits*. Search Press, 2006

Sidaway, Ian. *Colour Mixing Bible*. David & Charles, 2005

Stevens, Margaret and the Society of Botanical Artists. *The Art of Botanical Painting*. Harper Collins, 2004

Stevens, Margaret and the Society of Botanical Artists. *The Botanical Palette*. Harper Collins, 2007

West, Keith. *How to Draw Plants: The Techniques of Botanical Illustration*. The Herbert Press/British Museum, 1983

For more information about the Distance Learning Course from the Society of Botanical Artists, see www.soc-botanical-artists.org or telephone 01747 825 718.